The Campus History Series

THE CITADEL
and the
SOUTH CAROLINA CORPS OF CADETS

WILLIAM H. BUCKLEY

The Campus History Series

THE CITADEL
and the
SOUTH CAROLINA CORPS OF CADETS

WILLIAM H. BUCKLEY

ARCADIA

Published by Arcadia Publishing
Charleston SC, Chicago IL, Portsmouth NH, San Francisco CA

Printed in Great Britain

Library of Congress Catalog Card Number: 2004108191

For all general information contact Arcadia Publishing at:
Telephone 843-853-2070
Fax 843-853-0044
E-mail sales@arcadiapublishing.com
For customer service and orders:
Toll-Free 1-888-313-2665

Visit us on the internet at http://www.arcadiapublishing.com

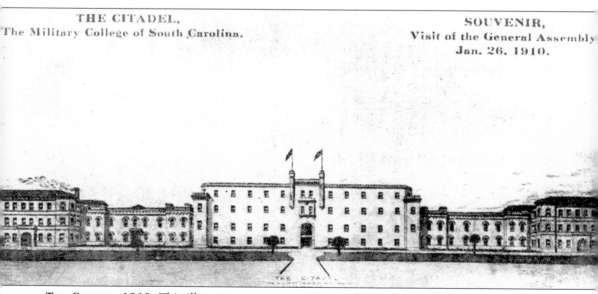

THE CITADEL, 1910. This illustration was given to members of the South Carolina General Assembly to commemorate their visit in January 1910.

CONTENTS

ACKNOWLEDGMENTS

This work is the result of the efforts of many dedicated Citadel alumni and friends, without whose assistance and encouragement it would not have been possible to complete this project.

The assistance of the staff at The Citadel has been exceptional. Ms. Patricia McArver, vice president for communications at The Citadel, and Ms. Jane Yates, director of The Citadel Museum and Archives, both provided invaluable help and access to documents, photographs, and other material, without which this book would not have been possible. The extraordinary images by Citadel photographer Russ Pace have contributed greatly to this work.

Many alumni who share my interest in Citadel history also provided much needed encouragement and help. It would be impossible to name them all, but I want to thank especially Randy Mitchell (Class of 1979) for his technical assistance and my classmates Bill Thomas and Len Kondratiuk for their interest in this project. Additionally, Dr. Walt Hood (Class of 1955), Rick Cox (Class of 1969), Glen Baldwin, (Class of 1970), Lucien Lane (Class of 1970), and Mike Rogers (Class of 1970) all made valuable contributions. Gary Baker (Class of 1966), Mike Blackwell (Class of 1969), and James Baldwin graciously allowed me access to research and photographs from their own books dealing with Citadel history. Finally, I am indebted to Chevis Clark, Henry Kidd, and the Company of Military Historians for allowing me to use their superb artwork.

My wife, Martha, and my daughters, Felice, Lisa, and Jocelyn, also provided great support and encouragement throughout this project and accepted the time constraints that this project required.

Finally, thanks are due to the staff at Arcadia for their continued assistance and forbearance, especially Laura New and Barbie Langston. It is impossible to name all who contributed, but everyone's efforts are greatly appreciated.

INTRODUCTION

For many years, Citadel publications contained a quote from John Milton: "I call therefore a complete and generous education one which fits a man to perform justly, skillfully, and magnanimously all the offices, both public and private, of peace and war."

This eloquent quotation summarizes the core goals of The Citadel in preparing its graduates both academically and morally to become productive citizens. The concept of the "citizen-soldier" has also been a central tenant of The Citadel philosophy throughout the more than 160 years of its existence.

The Citadel Board of Visitors recently adopted a mission statement codifying the mission of the college "to prepare Citadel graduates to become principled leaders in all walks of life by installing core values in a disciplined academic environment."

Throughout its history, The Citadel has created a legacy of service to the nation and state, in peace and in war. The contributions made by Citadel graduates go far beyond what could be expected of a school its size. Citadel graduates have fought in every American war since the Mexican War in 1846 and have been present at many pivotal events in American history. As this work is published, the first Citadel graduate has been selected for service as an astronaut. The Citadel has produced principled leaders in public life, in military service, in education, and all the professions. Citadel graduates have served as state governors, members of the U.S. Senate and House of Representatives, in senior military positions, as heads of prestigious academic institutions, and in the private sector.

In its history, The Citadel has survived epidemics, natural disasters, war, occupation, financial depression, and social unrest. It is a tribute to the leaders of The Citadel and its alumni that it has continued to exist at all.

This work was not intended to be a scholarly treatment of the history of The Citadel; that task is best left to professional historians. This book seeks to offer an overview of the history and traditions of The Citadel and the accomplishments of our alumni.

One of the founders of The Citadel, Gov. John Richardson, recognized the advantages to the state in offering a free education to "poor but deserving" young men in exchange for their performance of military duties and subsequent service to the state. This legacy of dedicated service, which has characterized The Citadel since its founding, continues as The Citadel moves into the future.

One

EARLY YEARS

Long before the establishment of the educational institution that would become the Military College of South Carolina, the colony of South Carolina had a proud military tradition dating back to 1670. During Colonial times, a Colonial militia was formed to defend against a possible attack from the Spanish colony at Saint Augustine to the south.

In 1780, during the British siege of Charleston in the Revolutionary War, a rampart called a "horn work fortification" was constructed in the vicinity of what is now Marion Square.[i] The defense of this fortification was led by the prominent South Carolinians Col. Charles Cotesworth Pinckney and Capt. Edward Rutledge.[ii] This property was later transferred by the State of South Carolina to the City of Charleston upon the city's incorporation on August 13, 1783, and six years later a small tract was transferred back to the state for use as a site for the inspection of tobacco.[iii] Charleston retained the remainder, which came to be known as the Citadel Green, as a muster ground for militia units. President George Washington toured the site and inspected the remnants of the old fortifications with some of the defenders during his Southern tour in 1791.[iv]

The site was converted to a state armory for the storage of weapons and ammunition in 1822, although the State Arsenal, as it was then known, was not ready for occupancy until 1829.[v] The building was designed by the noted Charleston architect Frederick Wesner (1788–1848), who also designed the portico on the South Carolina Society Hall at 72 Meeting Street. Wesner designed a two-story, Romanesque structure incorporating an interior courtyard with Doric columns and Roman arches. Some have speculated that Wesner's inspiration may have come from Jacques-Louis David's painting *The Oath of the Horatii*. [vi]

The state authorities also requested the facility be garrisoned by U.S. troops from Fort Moultrie on nearby Sullivan's Island rather than by state troops.[vii] The use of the term "Citadel" in state statutes referring to this facility first appeared in 1832, with the passage of an act "to provide for the security and protection of the State Citadel and Magazine in Charleston."[viii] In that year, as a result of the crisis precipitated by the passage of the Nullification Ordinance, whereby the State of South Carolina declared certain acts of the U.S. Congress null and void, state authorities also requested the removal of U.S. troops from

the Citadel, and South Carolina troops occupied the site for the next 10 years. In 1833, further legislation established two principal arsenals and magazines, one in Charleston and one in Columbia, and abolished the smaller arsenals scattered over the state. The Citadel in Charleston was already in use, and in 1838, the Arsenal in Columbia was completed.[ix]

Gov. George McDuffie had long been an advocate of military education, and in 1835 and 1836, he proposed combining military instruction with the usual subjects taught in state schools. In November 1842, Gov. John P. Richardson proposed replacing the militia garrisoning the arsenal in Columbia and the Citadel in Charleston with cadets of state military schools, thus providing an education for the "poor but deserving boys of the state." The cadets would be appointed by competitive examinations from each county in the state and would receive a free education in exchange for performing military duties at the two institutions. Other cadets could attend at their own expense.[x] Gen. David F. Jamison drafted the legislation that established the Arsenal Academy in Columbia and the Citadel Academy in Charleston. Each school would be separate but would be governed by a common board of visitors.

On March 20, 1843, a date now celebrated annually by the Corps of Cadets as "Corps Day," 20 cadets reported to the Citadel Academy and 14 to the Arsenal Academy. The academic year began on New Year's Day, and commencement was held in late November. The curriculum included courses in modern and South Carolina history, French, geometry, trigonometry, calculus, astronomy, military and civil engineering, physics, chemistry, intellectual and moral philosophy, political economy, international law, and infantry and artillery tactics.[xi] From March 1 through December 1, either artillery or infantry drill was held each day except Saturdays and Sundays. On Saturdays, the cadets stood room inspection and inspection under arms, and on Sundays, all cadets attended chapel.[xii] A young lieutenant from Fort Moultrie, William Tecumseh Sherman, was an occasional visitor to the Citadel Green during this early period.[xiii]

The first graduation was held on November 20, 1846, as South Carolina was preparing for the Mexican War. Citadel cadets trained the 1st South Carolina Volunteer Infantry, the Palmetto Regiment. This regiment's flag was the first to fly over Mexico City after its fall in 1847.[xiv] One of the first graduates, William J. Magill, served as a lieutenant in the 3rd U.S. Dragoons under Gen. Zachary Taylor in Mexico.[xv]

During the antebellum years, discipline and academic requirements were strict. Of the 550 cadets who attended the Citadel and the Arsenal during this first decade, 22 percent failed academically and 20 percent were dismissed for misconduct.[xvi]

The Association of Graduates, which would play a pivotal role throughout the history of the institution, was formed on November 19, 1852. The first president was Charles Courtney Tew, who had been the first honor graduate of the first graduating class in 1846.[xvii]

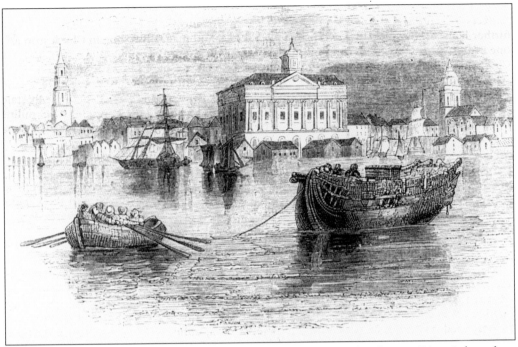

COLONIAL CHARLESTON IN 1780. This view of Charleston from the Cooper River is based on a drawing by Thomas Leitch, a noted London painter. The Old Exchange Building is in the center, and St. Michael's is the church to the left.

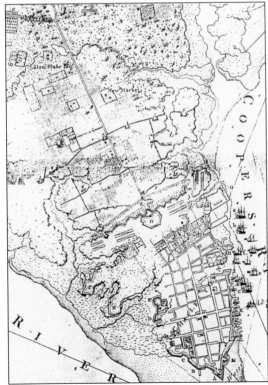

CHARLESTON HORN WORKS. Sir Henry Clinton's map of the siege of Charleston in 1780 shows the masonry horn work in the center, with the British siege lines above. President Washington visited this site during his Southern tour in 1791.

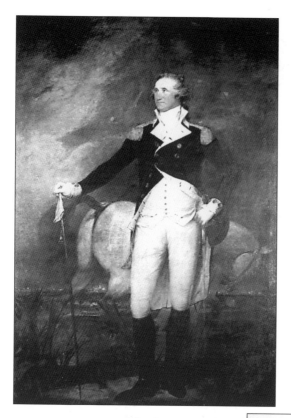

GEORGE WASHINGTON. This painting of George Washington by the noted painter Col. John Trumbull shows the President at Haddrells Point on May 2, 1791, with the Cooper River and Charleston behind him. While in Charleston, President Washington toured the site of what would become the Citadel Academy. The original hangs in the City Council Chamber in Charleston's historic City Hall.

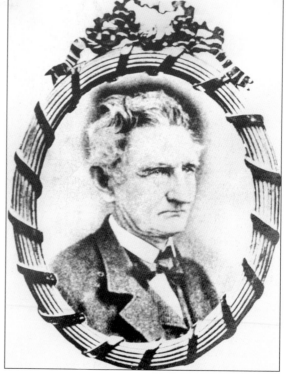

GOV. JOHN P. RICHARDSON. Governor Richardson is considered one of the founders of The Citadel. Before his service as governor, he had served in the U.S. Congress.

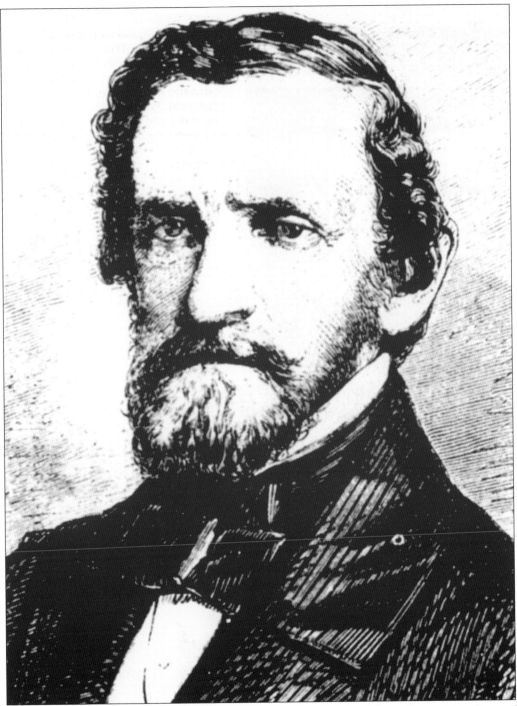

Gen. David Jamison. Gen. David Jamison served as chairman of the military committee of the South Carolina House of Representatives when legislation establishing the Citadel Academy was considered, and he served on the first Board of Visitors. Before the War Between the States, his daughter Caroline married Micah Jenkins, one of the most distinguished graduates during the war.

13

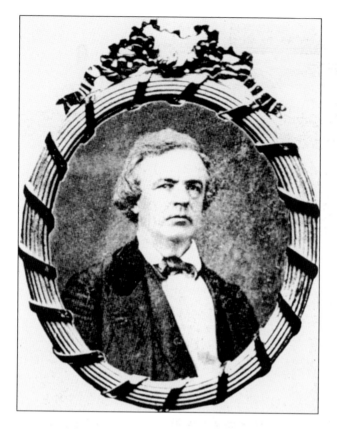

GEN. JAMES JONES. General Jones, a veteran of the Seminole War of 1836, had served as adjutant and inspector general of the State of South Carolina. He was appointed the first chairman of the Board of Visitors.

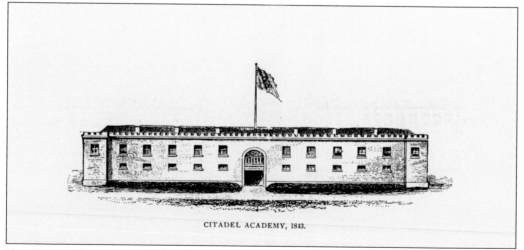

CITADEL ACADEMY, 1843.

THE CITADEL ACADEMY IN 1843. The Citadel Academy was originally a brick structure with a wooden parapet along the inner courtyard. Built in the Romanesque style, it set the tone for future construction on both the old and new campuses.

14

CADETS AT THE CITADEL ACADEMY IN 1843. This painting shows two cadets of the Citadel Academy in Ball or Hop Dress, along with a cadet officer and a faculty officer. This uniform, with minor changes, continues to be worn at full-dress formations. (Plate 91, *Military Uniforms in America, Years of Growth, 1796-1851*. Copyright The Company of Military Historians, 1977. Used with permission.)

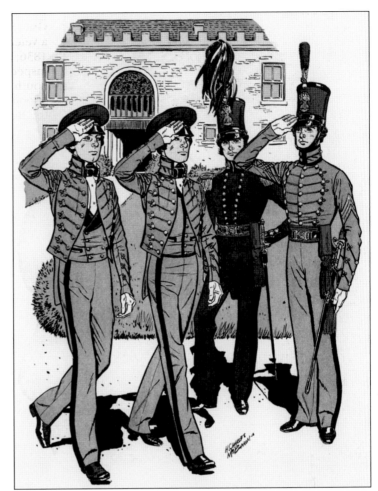

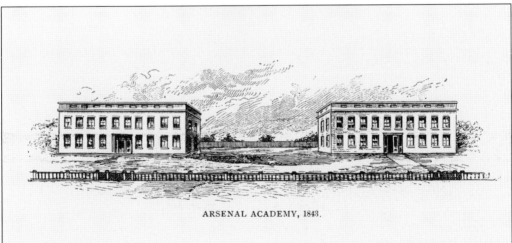

ARSENAL ACADEMY, 1843.

THE ARSENAL ACADEMY IN 1843. The Arsenal Academy in Columbia was originally envisioned as a separate institution. After 1845, only fourth-class (freshman) cadets trained at the Arsenal Academy.

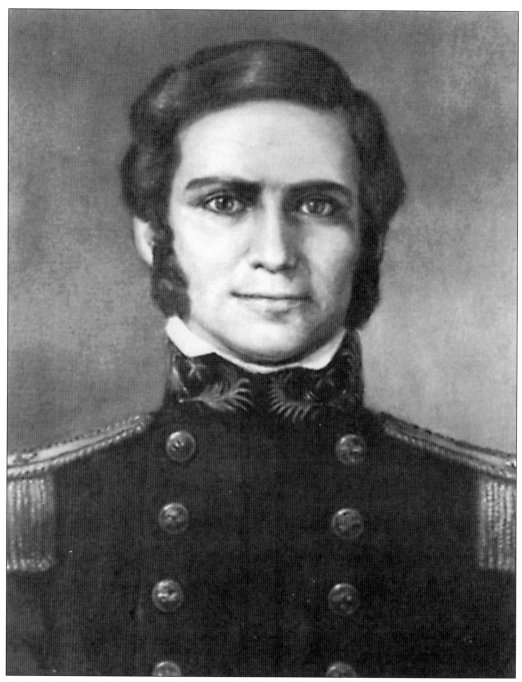

Maj. Richard W. Colcock. The second superintendent of the Citadel Academy, Major Colcock was a native of Beaufort, South Carolina, and an 1826 graduate of West Point. He replaced Capt. William F. Graham, who died at the Citadel after serving only 14 months. Major Colcock served from 1844 to 1852.

C.C. TEW, CLASS OF 1846. Charles Courtney Tew has been called the "proto-graduate" of the Citadel Academy, as the first honor graduate of the first graduating class. After graduation, he founded the Hillsboro Military Academy in North Carolina.

NORTH SALLY PORT OF THE OLD CITADEL. This sketch shows the view into what has been described as the Courtyard of a Thousand Arches.

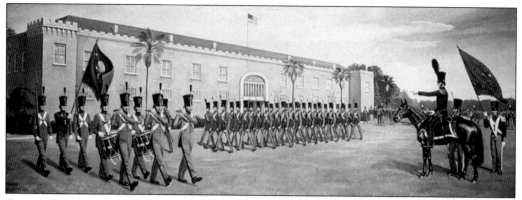

CADETS TRAINING WITH THE SOUTH CAROLINA VOLUNTEERS. Here, cadets train the members of the Palmetto Regiment on Marion Square during the Mexican War. Commissioned by Gen. Mark Clark, this painting was created by the distinguished artist David Humphries Miller as one of a series of murals depicting Citadel history. The original hangs in the Daniel Library.

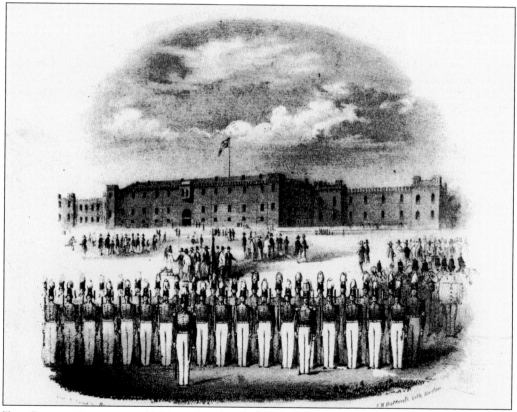

THE CITADEL ACADEMY IN 1850. "Who does not remember the Charleston company of the famed Palmetto Regiment when camped on Citadel Square? Who does not know the modest offer of the young cadets to initiate the company in the rudiments of infantry tactics; and who has forgotten the stately though juvenile forms of the cadets marching and commanding their seniors with all the confidence of veterans?" (Picture and quote courtesy of *Southern Quarterly Review*, November 1850.)

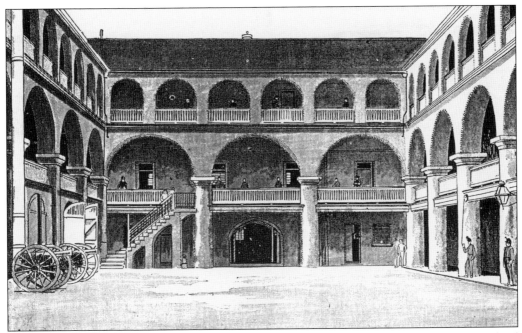

INTERIOR OF THE OLD CITADEL. The Courtyard of a Thousand Arches is shown here. The third story was added in 1849. This design was replicated when Padgett-Thomas Barracks was built in 1922 as the first barracks of the "Greater Citadel" when the campus was moved to the present Ashley River site.

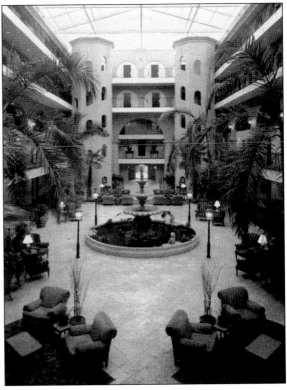

COURTYARD OF OLD CITADEL. The old Citadel has been refurbished for use as an upscale Charleston hotel. Local legends hold that the ghost of a cadet known as "Half-head" frequents the building.

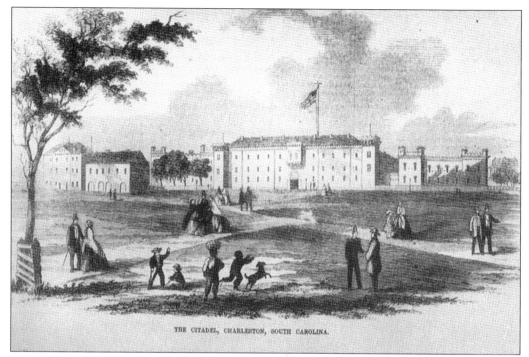

THE CITADEL, CHARLESTON, SOUTH CAROLINA.

THE CITADEL. *Harper's Weekly* described a view of "The Citadel, Charleston, S.C." as "a fine substantial structure, in the gothic style of architecture, well adapted for military purposes and is occupied as a State Military Academy, the course of instruction similar to that of the United States Military Academy at West Point, and fitted to turn out graduates who are both soldiers and gentlemen at home, in peace or war."

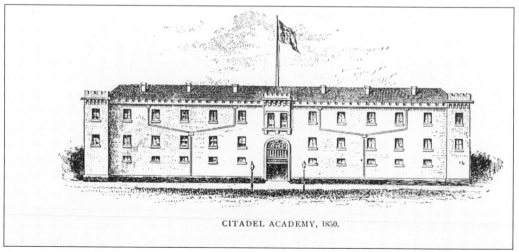

CITADEL ACADEMY, 1850.

THE CITADEL IN 1850. By 1850, a third story had been added to the original structure with four turrets with crenellations and an inner arcade of smaller arches. In 1854, two wings were added.

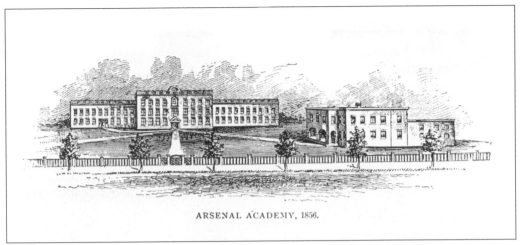

ARSENAL ACADEMY, 1856.

THE ARSENAL IN 1856. In 1852, a three-story, central building had been constructed that joined the two original wings into a single building. The building to the right was the officers' quarters, which is in use today as the South Carolina Governor's Mansion.

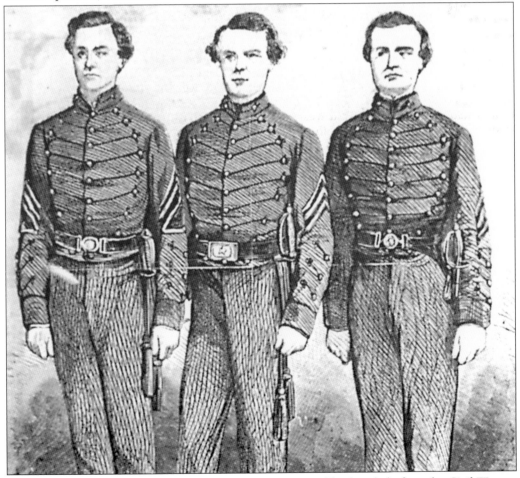

THREE CADETS. This engraving appeared in *Harper's Weekly* shortly before the Civil War.

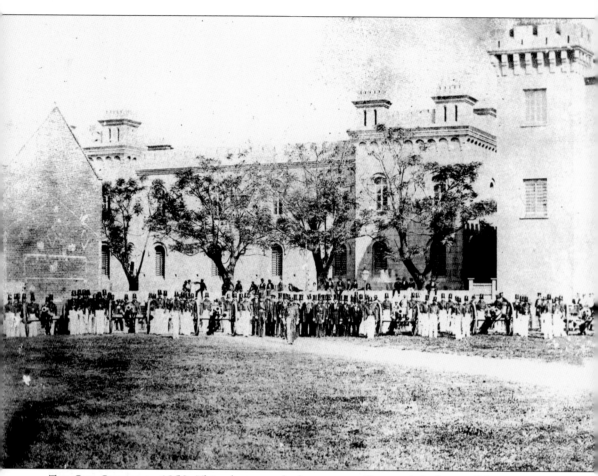

THE OLD CITADEL IN 1859. This photograph shows an artillery unit in front of the west wing of the old Citadel.

Two

WAR

Citadel graduates and cadets were active in the defense of Charleston Harbor after South Carolina seceded from the United States in December 1860.

Maj. Ellison Capers (Class of 1857) was among the first emissaries to the unfinished Fort Sumter in Charleston Harbor after the Union garrison evacuated Fort Moultrie on December 26, 1860.[xviii]

Citadel cadets, manning a battery of four guns and stationed on Morris Island, fired the first hostile shots of the War Between the States on January 9, 1861, repulsing the federal steamship *Star of the West,* which had been sent by President Buchanan to resupply Fort Sumter. The *New York Evening Post* reported, "The military men on board highly complimented the South Carolinians on their shooting in this first attempt. They say it was well done; that all that was needed was a little better range, which they probably could have obtained in a few minutes. Their line was perfect; and the opinion is expressed that some one had charge of the guns who knew his business."[xix]

On January 28, 1861, the South Carolina General Assembly passed legislation authorizing the use of cadets at both the Arsenal Academy and the Citadel Academy for military service. Each institution would retain their distinctive titles but would be known as The South Carolina Military Academy; the cadets would together constitute the Battalion of State Cadets.[xx]

When the bombardment of Fort Sumter began on the early morning of April 12, 1861, and full conflict erupted, Citadel graduates were present on many of the harbor batteries. Most living graduates served the Confederacy during the remainder of the war. R.A. Palmer (Class of 1852) was the first Citadel graduate to fall in battle at First Manassas in July 21, 1861. Evander M. Law (Class of 1856), as a lieutenant colonel of the 4th Alabama Regiment, also distinguished himself in this battle.[xxi] Two years later at Gettysburg, Brigadier General Law assumed command of his division at Devils Den and Little Round Top after Gen. John B. Hood was wounded.[xxii] Brig. Gen. Micah Jenkins was killed at the Battle of the Wilderness in 1864, in an accident remarkably similar to the death of Stonewall Jackson in the same area a year before. General Jenkins was one of Gen. James Longstreet's favorite

commanders and was a former brigade commander under Gen. George Pickett.[xxiii] Gen. Robert E. Lee had remarked of Jenkins, "I hope yet to see you one of my lieutenant generals."[xxiv] Two other graduates, Johnson Hagood and Ellison Capers, also served as brigadier generals, along with 19 colonels, 11 lieutenant colonels, 18 majors, and numerous junior officers and enlisted men. Of the 224 graduates living during the war, 209 served in the Confederate forces. Forty-nine graduates died for the South during the war.[xxv]

Citadel graduates fought in all major battles of the war. Capt. J.F. Hart (Class of 1857), served in the Horse Artillery under Maj. Gen. J.E.B. Stuart[xxvi], and Lt. James Thruston (Class of 1861), one of the cadets who had fired on the *Star of the West*, served in the Confederate Marines.[xxvii]

Citadel cadets took part in eight engagements in defense of Charleston and South Carolina during the war, earning the eight gray battle streamers on the Corps' Regimental Colors. Cadets from both the Citadel Academy and the Arsenal Academy fought together as the Battalion of State Cadets in the Battle of Tulifinny in December 1864. One Confederate soldier said of the cadets' conduct during this engagement, "Damned if they don't fight like Hood's Texicans."[xxviii] This engagement bought a delay of 10 days while the city of Savannah was evacuated. Twelve cadets died of either wounds or disease suffered in the field during the war.[xxix]

The pike on the regimental colors carries battle streamers for the following campaigns and engagements:

> *Star of the West*, January 9, 1861
> Wappoo Cut, November 1861
> James Island, June 1862
> Charleston and Vicinity, July to October 1863
> James Island, June 1864
> Tulifinny, December 1864
> James Island, December 1864 to February 1865
> Williamston, May 1865
> Confederate States Army[xxx]

In June 1862, some 36 cadets, in a well-planned effort, attended the usual daily routine of class, drill, and parade. After the evening meal, these cadets gave their names to the Cadet Officer of the Day, who shook hands with each departing cadet, and then left the institution to join the army.[xxxi]

The Cadet Company, also known as the Cadet Rangers, served as Company F, 6th South Carolina Cavalry, under Gen. Wade Hampton. The Cadet Company participated in the Battle of Trevilian Station in June 1864, the bloodiest cavalry engagement fought in the war. At one point in the battle, General Hampton saw that a Confederate battery was in danger of being overrun by Union cavalry. The only troops available to General Hampton were the Cadet Company. In a charge personally led by General Hampton, the cadets repulsed the Union troops and saved the guns.[xxxii]

Just as Citadel cadets and graduates were present at the beginning of the war in the *Star of the West* and Fort Sumter engagements, they were present at its conclusion. Maj. Robert M. Sims (Class of 1856), a member of Lieutenant General Longstreet's staff, carried the flag of truce from General Longstreet to Maj. Gen. George Armstrong Custer at Appomattox Court House.[xxxiii]

CADET FLAG IN 1857. The flag of the Citadel Corps of Cadets was presented by the Washington Light Infantry in 1857.

CADET FLAG IN 1857. The reverse of the cadet flag is seen here. This flag is displayed in the Citadel Museum.

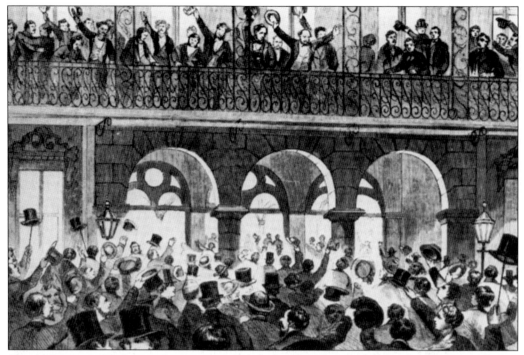

SOUTH CAROLINA SECESSION CONVENTION. South Carolina seceded from the United States on December 20, 1860, and remained an independent state until the formation of the Confederate government in February 1861.

ELLISON CAPERS (CLASS OF 1857). Ellison Capers graduated from the Citadel Academy in 1857 and returned in 1859 as a professor. During the Civil War, he served in South Carolina, rising to the rank of brigadier general. He was severely wounded during the campaign in Tennessee. After the war, he became an Episcopal minister and was a founder and chancellor of the University of the South in Sewanee, Tennessee.

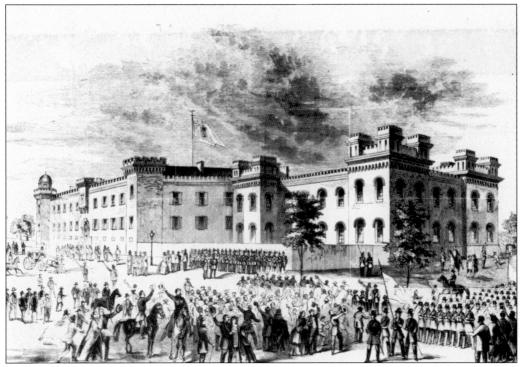

THE CITADEL ACADEMY IN 1860. This image shows the Citadel Academy viewed from the east, with one of the wings added to provide additional space.

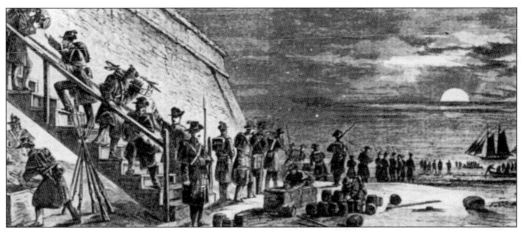

UNION GARRISON EVACUATES FORT MOULTRIE. The Union garrison secretly moved from Fort Moultrie on Sullivan's Island on December 26, 1860, to Fort Sumter in Charleston Harbor. Although unfinished, Fort Sumter offered a more defensible position.

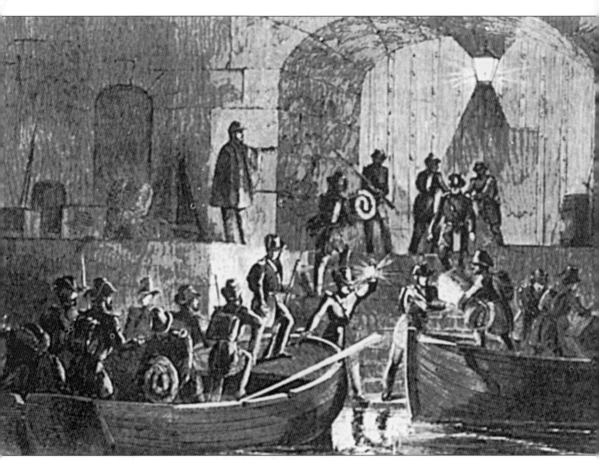

Union Garrison Enters Fort Sumter. After South Carolina authorities became aware that Major Anderson's garrison had occupied Fort Sumter, Col. J.J. Pettigrew and Maj. Ellison Capers, Class of 1857, were sent to demand an explanation.

Star of the West. The steamer *Star of the West* was dispatched from New York to resupply the Union garrison in Fort Sumter in January 1861. On January 9, 1861, the first shots of the War Between the States were fired by Citadel cadets from Morris Island, and the cadet battery, along with other batteries, repulsed the ship. It was later captured by Confederate forces and rechristened the CSS *St. Philip*. It was sunk on the Tallahatchie River above Fort Pemberton during the Vicksburg campaign.

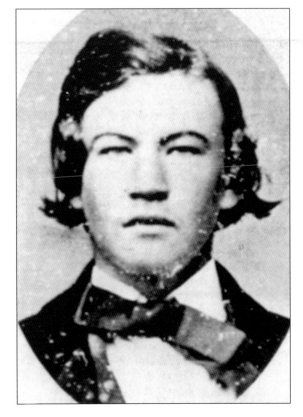

CADET WILLIAM S. SIMKINS (CLASS OF 1861). Cadet Simkins sounded the alarm to alert the cadets of the *Star of the West*'s appearance. During the war, he served as an officer in the 1st Regiment South Carolina Artillery. He later practiced law in Florida and Texas and then became a law professor at the University of Texas.

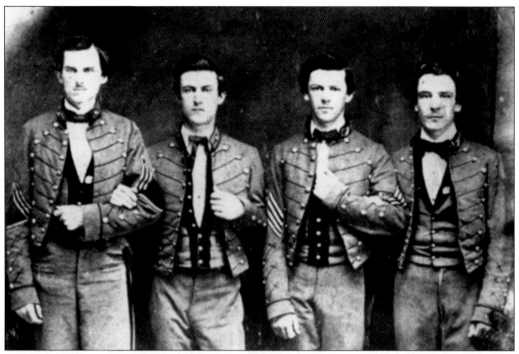

FOUR CADETS WHO FIRED ON THE *Star of the West*. The cadets are, from left to right, John Rufus Mew, William Wayne Gregg, William Fordham McKewn, and George Archibald McDowell. Only Mew survived the war.

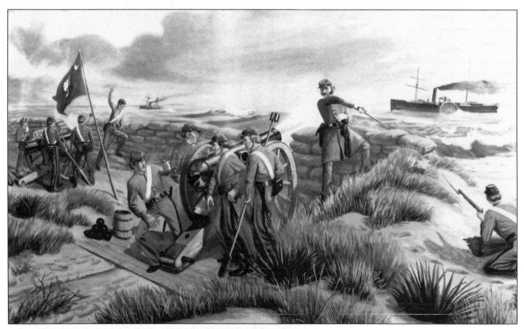

STAR OF THE WEST BATTERY. This mural by David Humphries Miller depicting the attack on the *Star of the West* hangs in the Daniel Library.

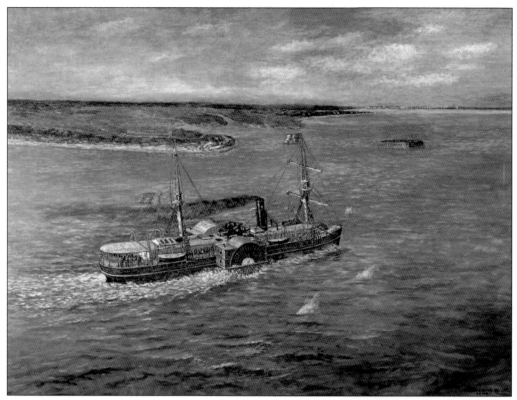

STAR OF THE WEST. This painting by Chevis Clark shows the *Star of the West* entering the channel to Fort Sumter. One of the officers on board joked, "The people of Charleston pride themselves on their hospitality, but it exceeds my expectation—they gave us several balls before we landed."

CADET J.M. WHILDEN (CLASS OF 1861). Cadet John M. Whilden commanded the cadet battery that opened fire on the *Star of the West*. He was mortally wounded at Second Manassas.

31

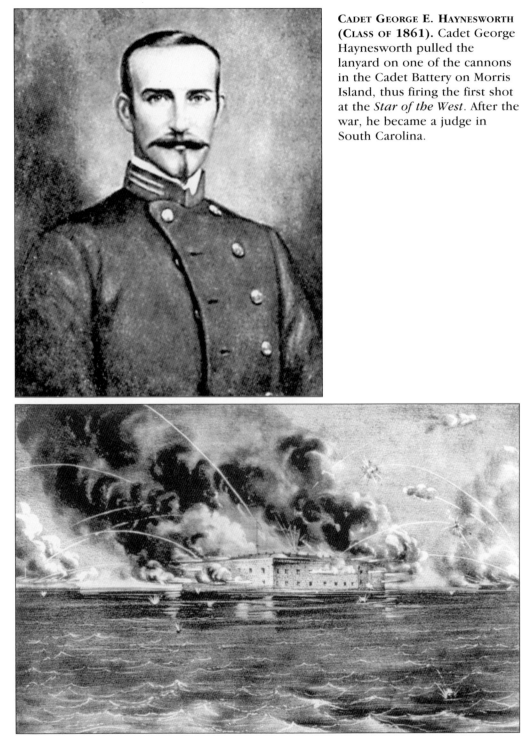

CADET GEORGE E. HAYNESWORTH (CLASS OF 1861). Cadet George Haynesworth pulled the lanyard on one of the cannons in the Cadet Battery on Morris Island, thus firing the first shot at the *Star of the West*. After the war, he became a judge in South Carolina.

BOMBARDMENT OF FORT SUMTER. Fort Sumter was bombarded on April 12, 1861, beginning the Civil War. A number of Citadel graduates were present during this bombardment in various units around Charleston Harbor.

Maj. J.B. White (Class of 1849). Maj. J.B. White served as superintendent of the Citadel Academy during the firing on the *Star of the West* and during the war. He commanded the Battalion of State Cadets at the Battle of Tulifinny.

John P. Thomas (Class of 1851). John P. Thomas served as superintendent of the Arsenal during the war. When the Citadel reopened in 1882, he was named superintendent.

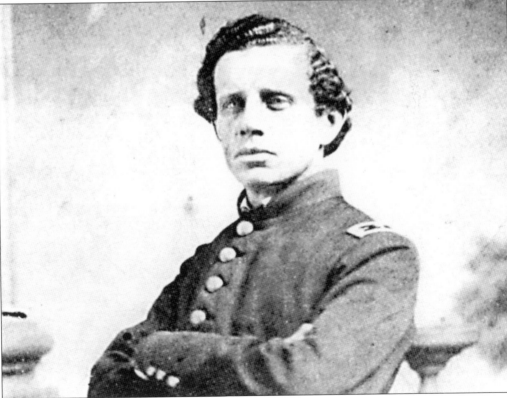

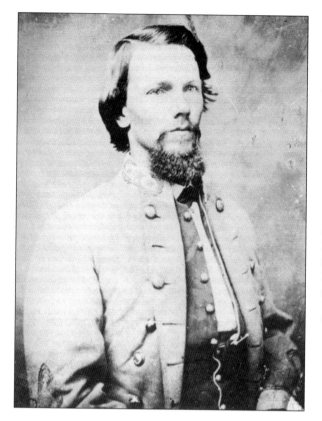

EVANDER LAW (CLASS OF 1856). After graduation in 1856, Evander Law taught at the Kings Mountain Military School, headed by Micah Jenkins and Asbury Coward. Law distinguished himself at First Manassas and was promoted to brigadier general in October 1862; at the time, he was the youngest general officer in the Army of Northern Virginia. His Alabama Brigade assaulted Little Round Top during the epic struggle at Gettysburg, and Law assumed command of Hood's Division after Hood was wounded. Law later served in Tennessee. After the war, he moved to Florida and was active in veterans' matters. He died in 1920, one of the last surviving Confederate generals.

GETTYSBURG. This view shows Little Round Top in July 1863. The struggle between the 20th Maine under Joshua Chamberlain and the 15th Alabama of Law's Brigade was one of the epic engagements of the war.

C.C. Tew (Class of 1846). Charles Courtney Tew was the first honor graduate of the first graduating class in 1846. He was also the first president of the Association of Graduates when it was organized in 1852. He was killed at Antietam while leading his regiment, the 2nd North Carolina, on the eve of being promoted to brigadier general.

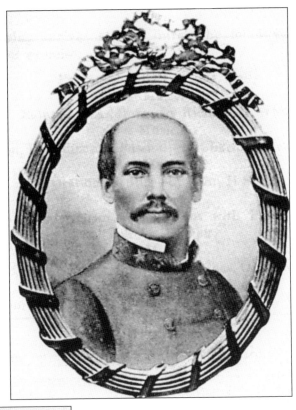

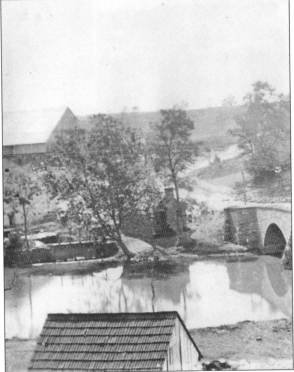

Burnside's Bridge at Antietam. Colonel Tew was accompanying Gen. John B. Gordon of Georgia in the vicinity of the "Bloody Lane" when he was killed. A Union soldier observed him mortally wounded, still clasping his sword, which was inscribed, "Presented to Captain C.C. Tew by the Arsenal Cadets of South Carolina."

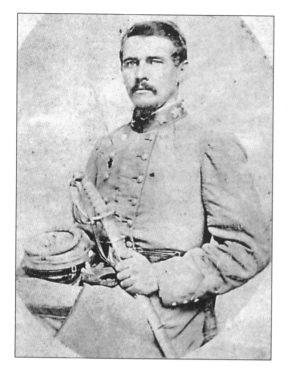

MICAH JENKINS (CLASS OF 1854). Micah Jenkins and his classmate Asbury Coward founded the Kings Mountain Military School in North Carolina after their graduation in 1854. When the war began, Jenkins became colonel of the 5th South Carolina Volunteers. He fought at First Manassas, the Peninsula campaign, and Fredericksburg. After promotion to brigadier general in 1862, he led Hood's Division at Lookout Mountain. He was mortally wounded at the Wilderness in May 1864. General Longstreet said that he was "one of the most estimable characters of the army. His taste and talent were for military service."

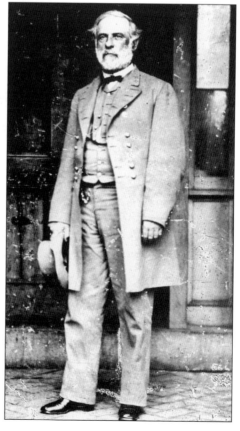

ROBERT E. LEE. Gen. Robert E. Lee said to Micah Jenkins, "I hope yet to see you one of my lieutenant generals."

EDWARD CROFT. Edward Croft (Class of 1856) was among the first Confederate officers to enter the town of Gettysburg on July 1, 1863.

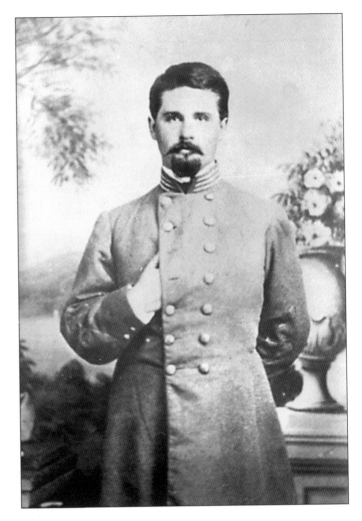

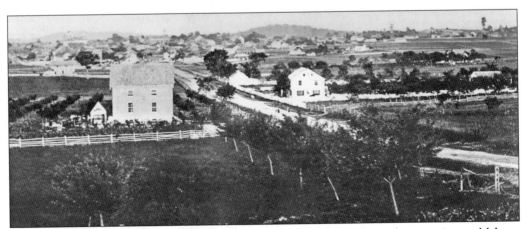

CONFEDERATE TROOPS ENTERING GETTYSBURG. This view shows Gettysburg as it would have appeared to the first Confederates to enter town on July 1, 1863.

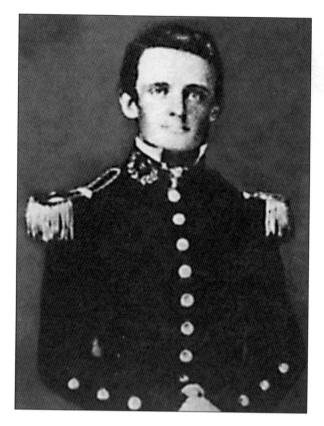

ASBURY COWARD (CLASS OF 1854). Colonel Coward commanded the 5th South Carolina Infantry during the war and was present at the death of his friend and classmate Micah Jenkins at the Wilderness. Robert E. Lee said of Coward that he considered him one of the ablest officers of the army. He became superintendent in 1890.

WARTIME CHARLESTON. This view shows White Point Gardens at the Battery during the war.

CAPT M.B. HUMPHREY (CLASS OF 1864). Capt. Moses Benbow Humphrey led the cadets who left the Citadel to form the Cadet Company. He was killed in 1865, just as the war was ending.

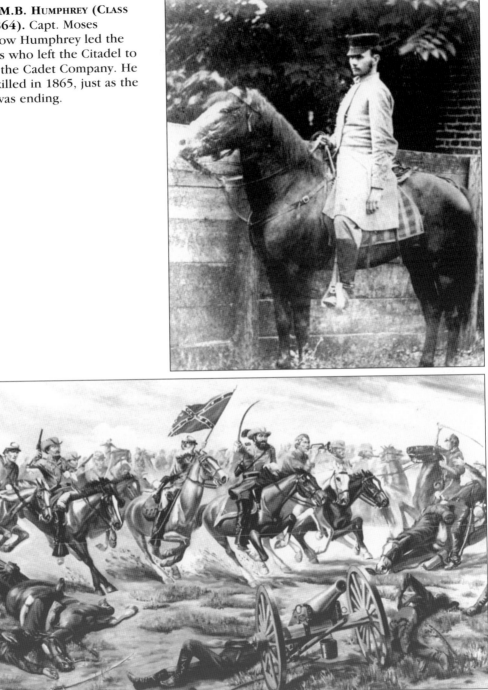

CHARGE AT TREVILIAN STATION. Members of the Cadet Company fought in the Battle at Trevilian Station, the bloodiest cavalry engagement fought in the war. Union cavalry threatened a battery of Confederate artillery, and Gen. Wade Hampton, who commanded Lee's cavalry after the death of J.E.B. Stuart, led the cadets in the charge to save the guns. The battery of cannon was commanded by Capt. J.B. Hart, Class of 1857.

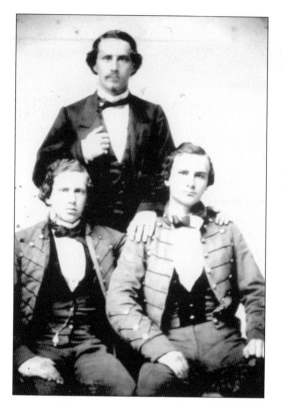

MOSES BROTHERS. The three Moses brothers of Sumter, South Carolina, are pictured, two of whom are in Citadel cadet uniforms. Joshua Lazarus Moses, standing, was killed at Fort Blakeley, where his brother Perry, right, was wounded. Isaac Harby Moses, Class of 1861 (left), was a member of the *Star of the West* Battery and also served as a member of the Cadet Company at Trevilian Station. After the war, he was a successful businessman in New York City.

JOHNSON HAGOOD, CLASS OF 1847. Johnson Hagood practiced law before the war. As a Confederate general, he served in the Carolinas and Virginia. He served as governor of South Carolina from 1880 to 1882.

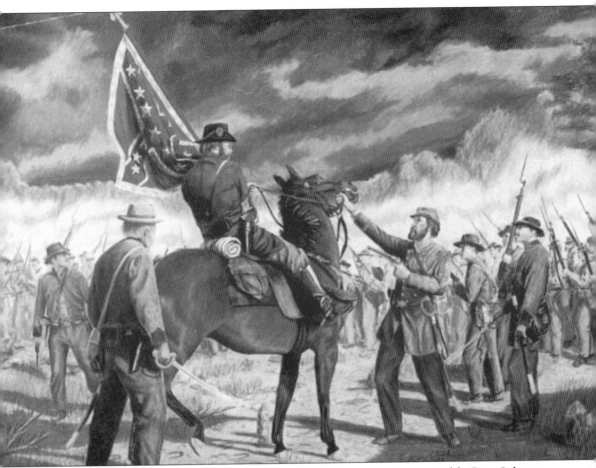

"Iron Courage and Southern Chivalry." In this painting by Henry Kidd, Gen. Johnson Hagood has approached a Union officer from the Iron Brigade who has captured a Confederate battle flag during the Battle of Petersburg. General Hagood offered the officer safe passage in exchange for the flag. The officer refused. General Hagood again extended the offer. When the officer again refused, General Hagood shot and wounded him. After the war, General Hagood assisted the officer in obtaining a pension, and the two reportedly became friends.

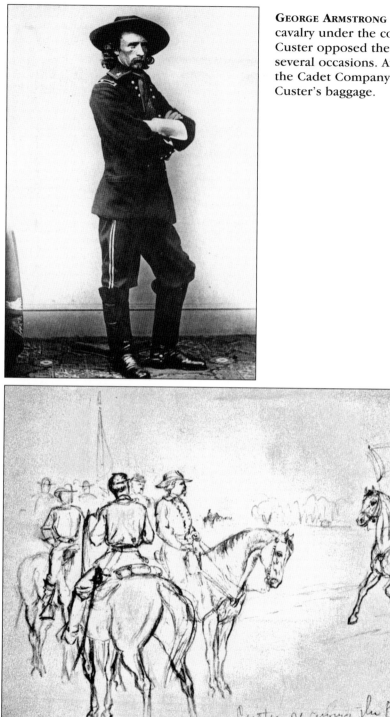

GEORGE ARMSTRONG CUSTER. Union cavalry under the command of General Custer opposed the Cadet Company on several occasions. At Trevilian Station, the Cadet Company nearly captured Custer's baggage.

FLAG OF TRUCE AT APPOMATTOX. This drawing by the noted Civil War artist Albert Waud shows Maj. Robert Sims (Class of 1856), an officer on the staff of General Longstreet, carrying a flag of truce to General Custer at Appomattox Court House, which ended the fighting.

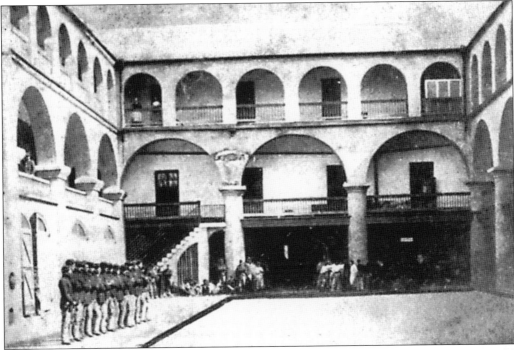

UNION TROOPS IN THE OLD CITADEL QUAD. After the end of hostilities, Union troops would occupy the Citadel for the next 17 years.

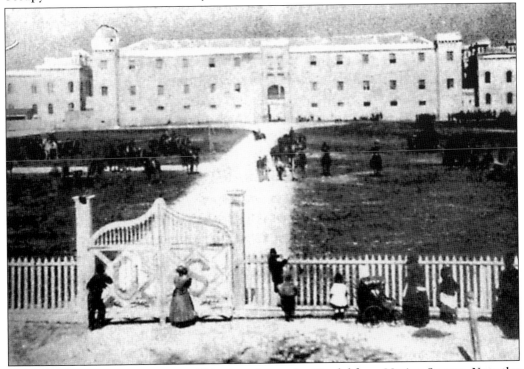

UNION TROOPS IN MARION SQUARE. This view shows the Citadel from Marion Square. Note the "U.S." on the gate.

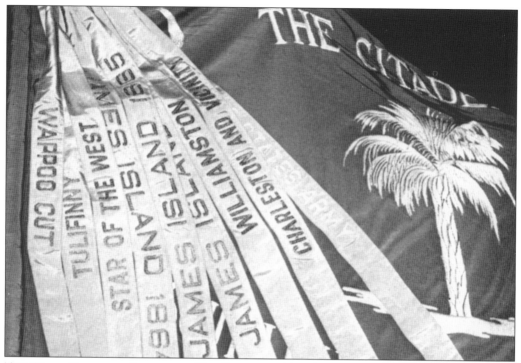

THE CORPS FLAG WITH STREAMERS. The flag carried by the South Carolina Corps of Cadets carries nine battle streamers for service rendered during the Civil War.

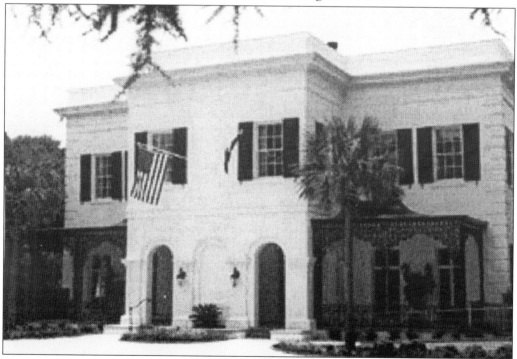

THE SOUTH CAROLINA GOVERNOR'S MANSION. The Governor's Mansion in Columbia is all that remains of the Arsenal Academy.

Three

REBIRTH AND GROWTH

The Citadel in Charleston was occupied by Union troops for 17 years after the war. The Arsenal Academy in Columbia had been entirely destroyed during Sherman's capture of the city and would never reopen. The officers' quarters, however, survived, and they are used today as the Governor's Mansion.

Efforts to reopen the Citadel began almost immediately. The Association of Graduates was revived and met in December 1877 in the armory of the Washington Light Infantry.[xxxiv] Brig. Gen. Johnson Hagood (Class of 1847) was elected president, a position he held until his death in 1898.

The reorganized alumni intensified their efforts to secure legislation in the U.S. Congress to obtain the return of the Citadel property from the federal government and in the South Carolina General Assembly to revive the school. After a dedicated and determined effort, the legislation to reopen the South Carolina Military Academy was passed by the General Assembly in January 1882, and possession of the Citadel returned to the State on March 7, 1882.[xxxv] One hundred eighty-nine cadets reported to the revived Citadel on October 2, 1882. Col. John P. Thomas (Class of 1851), who had served as superintendent of the Arsenal Academy during the war, was appointed superintendent.

The reopened Citadel continued most of the policies and traditions of the old Citadel Academy, including the admission of beneficiary, or scholarship, cadets as well as pay cadets. Colonel Thomas, determined to reestablish the same military system that had distinguished the academies before the war, reinstituted the traditional discipline system.[xxxvi]

In 1885, Cadet James T. Coleman won the title of "Best Drilled Cadet in the United States" in a competition in New Orleans, thus validating the standards of the reopened institution.[xxxvii] In 1886, the annual competition began for the *Star of the West* Medal, to be awarded to the "Best Drilled Cadet," and the medal was first awarded to Cadet A.E. Legare.[xxxviii] This annual competition has continued to the present. The medal features a sliver of wood from the vessel itself.

Col. Asbury Coward (Class of 1854) assumed the office of superintendent in 1890. Coward had served as commanding officer of the 5th South Carolina Volunteers and was

present at the death of his friend and classmate, Gen. Micah Jenkins, at the Wilderness.[xxxix] When his regiment surrendered at Appomattox, Coward received a written commendation from Robert E. Lee that stated, "I have always considered [Colonel Coward] one of the best officers of this army."[xl]

The first commandant of cadets—1st Lt. John A. Towers, 1st U.S. Artillery—was appointed in 1890 and assumed responsibility for disciplinary matters in the Corps of Cadets, which had formerly been among the responsibilities of the superintendent.[xli] In May 1893, Lt. John M. Jenkins of the 5th U.S. Cavalry, a graduate of West Point and the son of Brig. Gen. Micah Jenkins (Class of 1854), was appointed as commandant.[xlii] The report of the inspector general of the army in 1894 described the Citadel as "a military school in the best sense of the term, . . . [it] equals any organization in the army."[xliii]

When the Spanish-American War erupted in 1898, a number of Citadel graduates served with volunteer regiments. Five graduates served with the regular army, including Capt. W.H. Simons (Class of 1890), who was wounded at the Battle of Santiago. In 1904, Captain Simons became commandant of cadets.[xliv]

Many Citadel graduates moved to the West in the period following the war. These graduates were involved in the westward expansion of the United States during this period, serving as surveyors and engineers.[xlv]

Baseball began at the Citadel in 1886. Cadets fought for several years for permission to begin a football team, and the Board of Visitors granted permission in 1905. The first basketball team was started in 1913.

A graduate of the first class after the institution reopened, Col. Oliver J. Bond (Class of 1886), was appointed superintendent in 1908. In 1910, Colonel Bond changed the name of the school to "The Citadel, the Military College of South Carolina." Colonel Bond believed that the term academy had become increasingly associated with secondary schools.[xlvi] In 1921, the title of the head of the institution was changed from a superintendent to a president.

First-class cadets were allowed to choose an elective or major from civil engineering, the sciences, or literature beginning in 1903. In 1916, this system was extended to the second class. In 1910, The Citadel was empowered to grant the degree of civil engineer, and the physical facilities of the old Citadel were completed in 1911 with the addition of a fourth story to the original building.

As the nation prepared for World War I, the National Defense Act of June 3, 1916, established the Reserve Officers Training Corps and thus allowed a number of Citadel graduates to enter the regular army. Of the Class of 1917, all entered the military service.

During World War I, Citadel graduates served with great distinction. Montague Nichols, serving with the British Royal Horse Artillery in Flanders, was the first Citadel alumnus to be killed in action.[xlvii] The first officer from South Carolina to fall in battle was Lt. John H. David, Class of 1914.[xlviii]

The record of Citadel graduates is eloquently described by Barnwell R. Legge (Class of 1911), who won the Distinguished Service Cross in France. He was later a brigadier general and during World War II served as the military attaché to Switzerland, working with Allen Dulles, who later headed the Central Intelligence Agency.[xlix] In his remarks to the alumni banquet in Columbia in 1920, Captain Legge stated:

> When the first American convoy sailed on June 13, 1917, there were a number of Citadel men with it. They were with the artillery brigade that pulled its guns up through the mud of Lorraine, and going into position near Bathlemont, sent America's first shot into the German lines. . . . Three hundred and fifteen in the service of their country; six killed, seventeen wounded. The war is over. Citadel men still serve, from the island of Mindanao to the steppes of Siberia. The mills of the old institution grind slowly—the product changes not. It stands for the same principles, the same ideals—solid citizenship, unquestioned loyalty, unflinching service."[l]

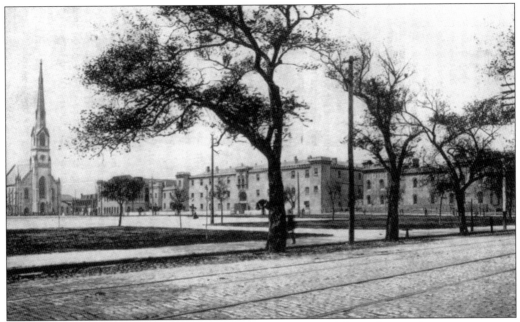

THE CITADEL IN THE 1890s. This view shows the old Citadel from the southeast.

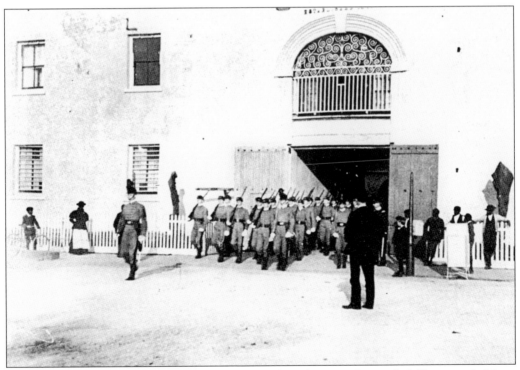

A CITADEL PARADE IN 1890. During this period, cadet parades and drills were held on Marion Square.

A LAMP DETAIL IN 1890. During this period, it was the responsibility of the cadet room orderly to make certain that the lamps in the cadet rooms were adequately filled.

JOHN M. JENKINS. John M. Jenkins was one of Micah Jenkins's sons. He was educated at Kings Mountain Military School by his father's friend and classmate Asbury Coward. Jenkins graduated from West Point and was later commandant of cadets at The Citadel. He served in World War I and retired from the army as a major general.

ASBURY COWARD (CLASS OF 1854).
Asbury Coward founded the Kings Mountain Military School with Micah Jenkins. After distinguished service in the Army of Northern Virginia, he was superintendent of the Citadel from 1890 to 1908.

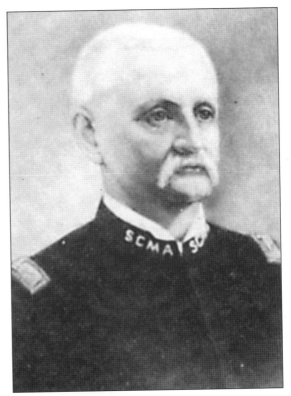

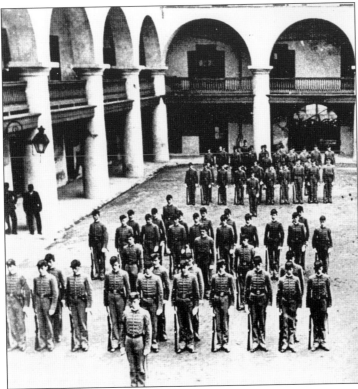

CADETS ON THE QUADRANGLE IN 1890. Cadets are shown forming up for parade. The Civil War–era Kepi was still worn during this period.

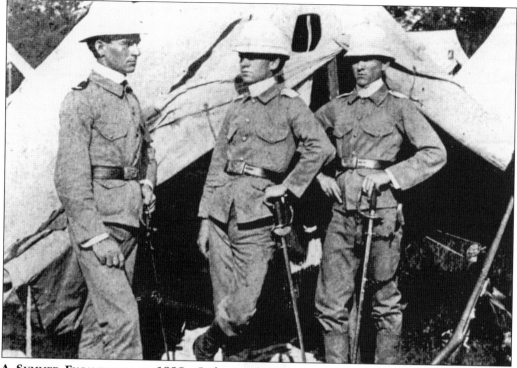

A Summer Encampment in 1898. Cadets participated in field training around the state, including the area that eventually became the new home of The Citadel.

Morning Inspection in 1900. The routine of morning inspections continues to the present.

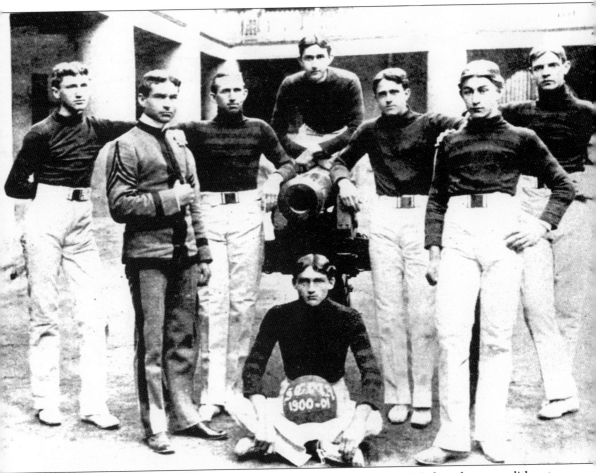

THE 1900 BASKETBALL TEAM. Basketball began at the Citadel in 1900, but the team did not have a coach until 1913. That season, the cadets played only five games. The Citadel basketball team won its only contest with the University of Kentucky in 1927, a record of which few schools can boast.

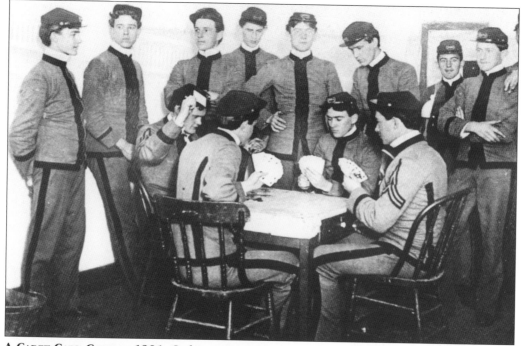

A Cadet Card Game in 1901. Cadets enjoy a rare moment of free time.

Punishment Tours in 1901. In 1901, as now, cadets who are "awarded" excess demerits or who violate some other disciplinary regulation walk punishment tours.

CADETS ON THE QUAD IN 1902. This photograph is notable for the use of the short-lived white helmets, adopted by the U.S. military in the post–Civil War period.

CAPT W.H. SIMONS (CLASS OF 1890). Capt. William H. Simons entered the regular army and was wounded at the Battle of Santiago during the Spanish-American War. He was the first Citadel graduate to serve as commandant of cadets.

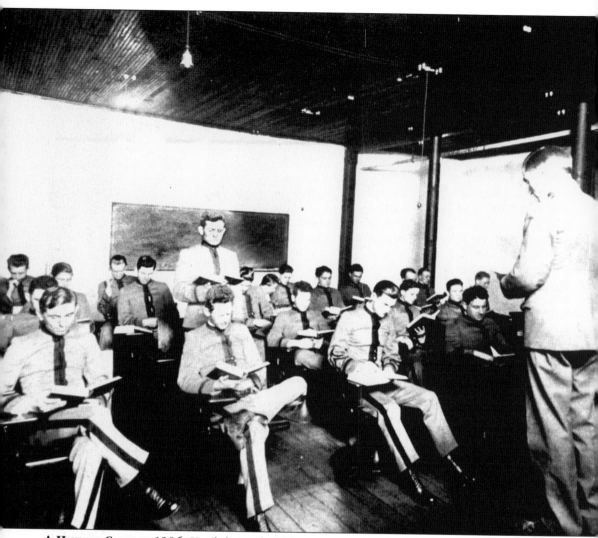

A History Class in 1906. Until the early 20th century, cadets were required to attend class in the dress uniform.

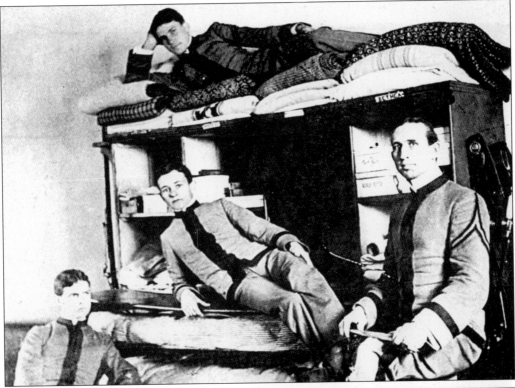

A Cadet Room in 1907. During this era, cadets were required to break down their beds during the day.

Col O.J. Bond (Class of 1886). Col. Oliver J. Bond served as superintendent and president from 1908 to 1931. During his administration, The Citadel moved to its present location and greatly improved its academics.

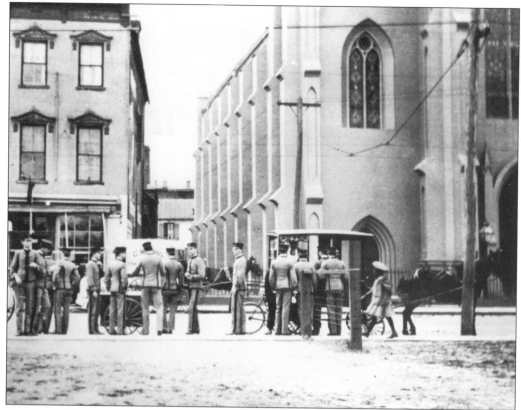

CADETS ON KING STREET IN 1910. Cadets were allowed to purchase food from vendors on Marion Square.

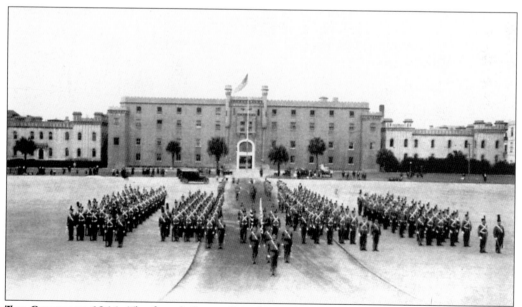

THE CITADEL IN 1911. The fourth floor of the barracks was added in 1910.

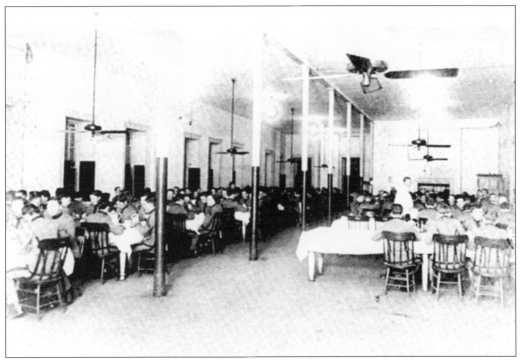

THE MESS HALL IN 1914. The Corps of Cadets has always attended meals as a unit, fostering a sense of camaraderie and spirit. The entire corps continues to eat at the same time.

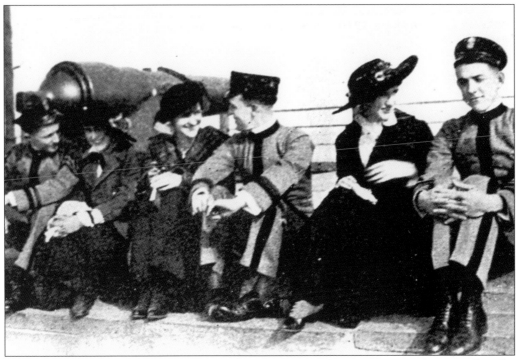

CADETS AND THEIR DATES IN 1915. These cadets and their dates are seen at the seawall at the Battery at White Point Gardens.

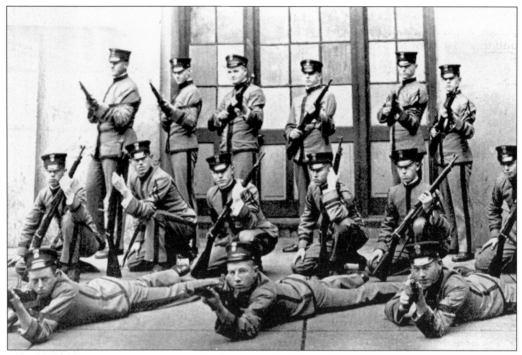

THE RIFLE TEAM IN 1917. The Citadel has long fielded a strong rifle team, winning numerous championships.

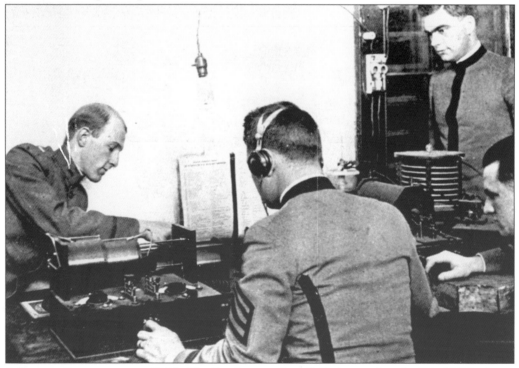

A PHYSICS LABORATORY IN 1914. The faculty member (left) is wearing the World War I–era uniform, and the cadets wear the dress uniform even in the laboratory.

WORLD WAR I CADETS. Cadets parade down King Street in their uniforms just prior to World War I.

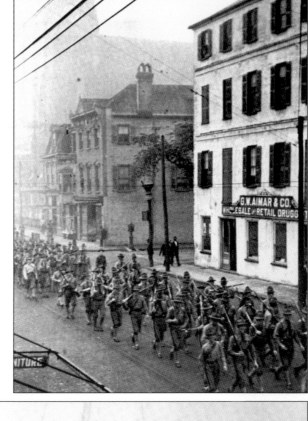

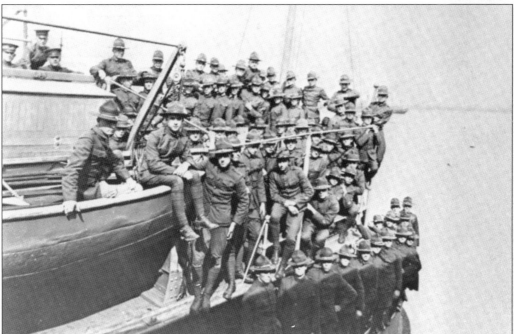

WORLD WAR I CADETS. Some cadets are shown in "dough-boy" style uniforms, practicing a landing exercise.

LEGGE MURAL. This mural by David Humphries Miller commemorates the World War I service of Capt. Barnwell Legge.

Four

THE GREATER CITADEL

A seminal event in the history of The Citadel was the building of the "Greater Citadel." With the addition of the fourth floor of the old building in 1910, the Corps of Cadets had reached its maximum strength of 325 cadets. In addition, Marion Square was increasingly used by the general public, limiting its use as a drill field. The business center of the city had become the intersection of King and Calhoun Streets, adding further congestion to the campus.

Recognizing that The Citadel could not continue to grow and remain at the old Marion Square location, in 1918, the City of Charleston offered the State land on the Ashley River, within the old Colonial estate of John Gibbs[li], for the building of the new campus. The City had once planned to use this land as an extension of Hampton Park, and the noted landscape architect Frederick Law Olmsted of Boston had laid out a plan for the park, including the area known as Indian Hill, the highest point in Charleston. Cadets had long used this area as a site for field exercises.[lii] Just across the Ashley River was the site of the first English settlement at Charlestown in 1670, where the colony was located for 10 years before the colonists moved to the peninsula.

Some consideration was given to relocating The Citadel to another part of the state. Sullivan's Island had been considered during the War Between the States as a site for the Citadel Academy. James Island was also considered, as was the upstate. It was eventually decided wisely that The Citadel was so closely identified with the city of Charleston that it could not be moved. In 1919, the South Carolina General Assembly favorably considered the legislation to relocate The Citadel. The Board of Visitors selected as builder R.M. Walker of Atlanta, who had been the first honor graduate of the first post-bellum class of 1886. Unfortunately, Mr. Walker died before his work could be completed.

On Thanksgiving Day, November 25, 1920, the dedication ceremony was held and work formally began on the Greater Citadel. Within two years, the first barracks, later named Padgett-Thomas Barracks, the wings of Bond Hall, and other auxiliary buildings had been constructed. The Romanesque style of architecture was followed in the new buildings, and the use of arches and courtyards replicated the old Citadel.

As evidence of its increasing academic reputation, The Citadel was elected to membership in the Southern Association of Colleges on December 5, 1924. In 1929, the Board of Visitors was granted the privilege of granting honorary degrees.

The last graduation exercises at the old Citadel were held on June 13, 1922, at Hibernian Hall. The class numbered 54 graduates, the largest class in the history of The Citadel up to that time.[liii] After 80 years, the cadets of The Citadel left their former home on the Citadel Green.

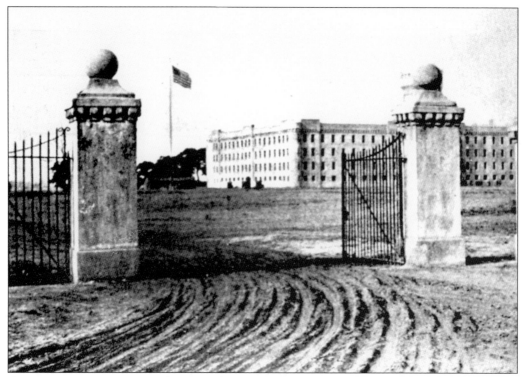

THE NEW CITADEL IN 1922. This view shows the entrance to the new campus.

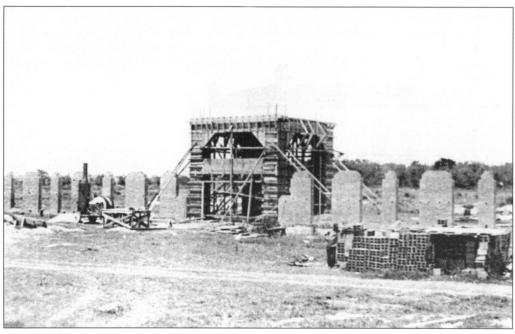

PADGETT-THOMAS FOUNDATION. Padgett-Thomas Barracks were the first barracks to be constructed. Its tower has become the symbol of The Citadel.

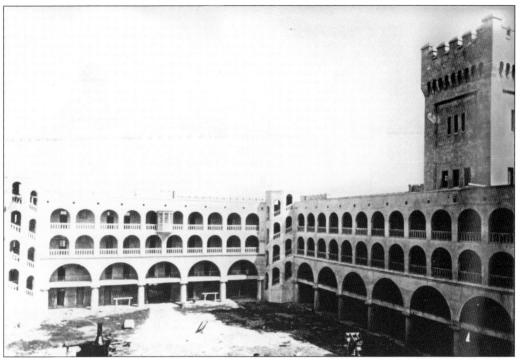

Padgett-Thomas Construction. The first of the four cadet barracks, this facility is named for Col. J.G. Padgett, Class of 1892, and for Col. John Pulaski Thomas, Class of 1893, both of whom served on the Board of Visitors.

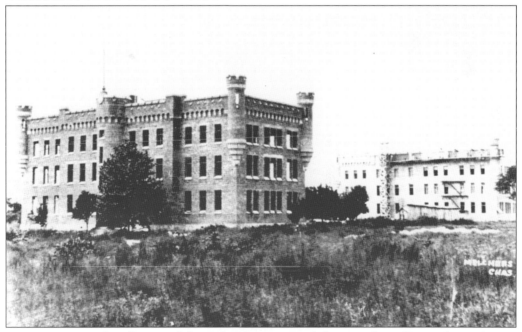

Bond Hall. Bond Hall, named for Col. Oliver J. Bond, houses the college administration and several academic departments. It was the first academic building constructed on the new campus.

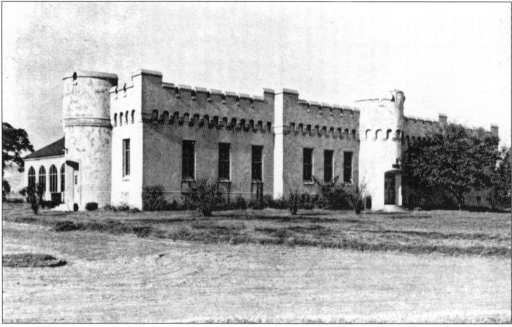

HOSPITAL. The hospital was funded by a donation from the Murray family of Charleston, for whom the Murray Barracks are also named.

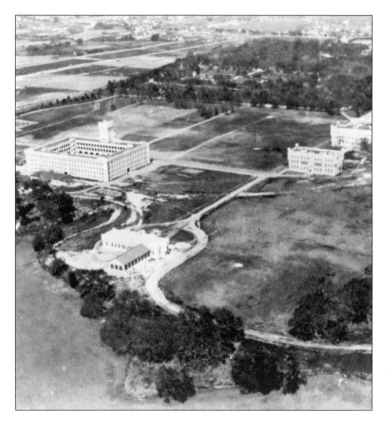

1923 AERIAL VIEW OF CAMPUS. This early view of the Ashley River campus shows only Padgett-Thomas Barracks, the cadet hospital, and the two wings of Bond Hall.

Maj. Gen. James T. Moore. Maj. Gen. James T. Moore (Class of 1916) was one of the pioneers of Marine Corps aviation. During World War II, he commanded Marine aviation in the Pacific.

Capt. J.T. Moore. While in China in the late 1920s, then-Captain Moore served in the 3rd Brigade under the command of Smedley Butler, one of the legends of the Corps. General Butler had the Marines perform demonstrations of their skill for the benefit of the Chinese. At one such event, Captain Moore was performing some daring acrobatics when both of the wings of his plane broke off. Captain Moore was able to parachute to safety, and he landed in a moat just in front of the bleachers. "Trust Smedley," a woman spectator commented. "He always puts on a great show." The parachute is visible just to the right of the pole in the center of the picture.

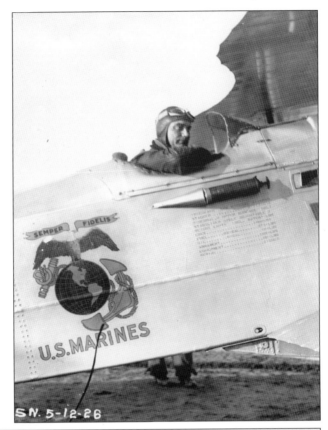

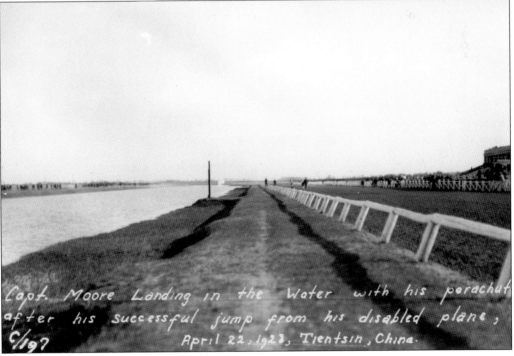

Capt. Moore Landing in the Water with his parachut after his successful jump from his disabled plane, April 22, 1928, Tientsin, China.

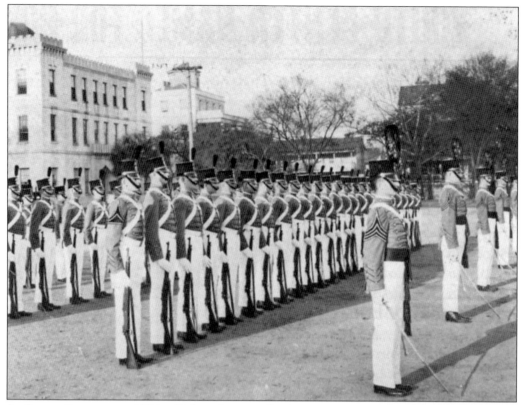

A Cadet Parade in 1921. Cadet Capt. William O. Brice (Class of 1921) is shown commanding his cadet company. He would retire as a four-star general in the Marine Corps.

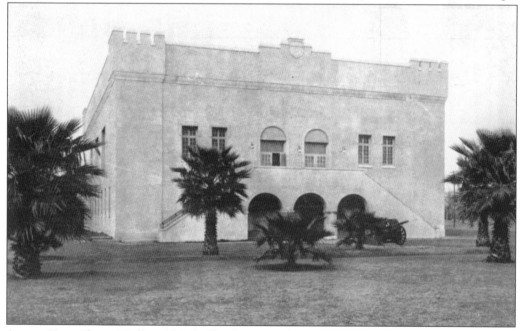

Alumni Hall. Alumni Hall was funded by donations from alumni and housed athletic facilities.

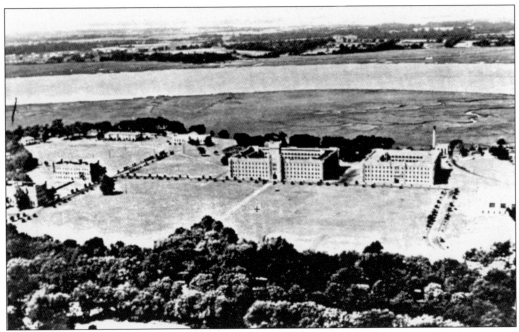

THE CITADEL IN 1925. This view looks west across the Ashley River.

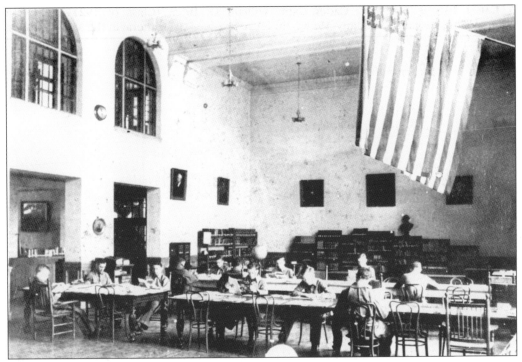

THE LIBRARY IN 1925. The old library was located in Bond Hall.

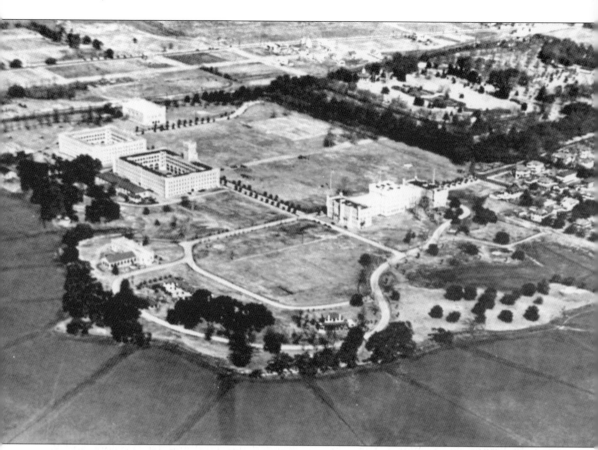

THE CITADEL IN 1934. This view of the campus shows two barracks, Alumni Hall, the completed Bond Hall, and faculty quarters.

Five

SUMMERALL AND CLARK

A new era for The Citadel began in 1931 when Gen. Charles Pelot Summerall assumed the presidency of The Citadel, upon his retirement as chief of staff of the U.S. Army. During the Boxer Rebellion in China in 1900, General Summerall had distinguished himself by taking his artillery guns through heavy fire to a position where the gates of Peking could be blasted open. In France during World War I, he commanded the 42nd and 1st Divisions and V Corps of the American Expeditionary Force. After the war, he served as a member of the Allied Mission of Generals at Fiume and was attached to the American Commission to negotiate peace in Paris at the close of World War I.

General Summerall provided steady and principled leadership, which enabled The Citadel to survive the Great Depression during the 1930s. Under his leadership, the campus was greatly expanded with the construction of LeTellier Hall; the Summerall Chapel; Capers Hall; the Armory, now known as McAlister Field House; and Law and Stevens Barracks.

During World War II, The Citadel had the distinction of having the highest percentage of its students enter the military service of any college, with the exception of the service academies.[liv] Before Pearl Harbor, some Citadel alumni served in the armed forces of allied nations. Of 2,976 living graduates in 1946, 1,927 had served their country. Before the end of the war, 280 Citadel men had given their lives.[lv]

While many cadets and graduates were serving in the armed forces, the facilities of The Citadel also contributed to the war effort. As the number of cadets decreased, The Citadel faculty taught soldiers participating in the Army Specialized Training Program; Engineering, Science, and Management War Training; the Army Specialized Training and Reassignment Program; and Specialized Training and Reassignment. These programs screened and prepared soldiers for Officer Candidate School and other assignments.[lvi]

Maj. Thomas D. Howie (Class of 1929) earned international fame as "The Major of St. Lo." After a distinguished cadet career, where he achieved both academic and athletic success, Howie taught English literature at Staunton Military Academy in Virginia. At Staunton, Howie also served as a coach and as an officer in the Virginia National Guard. In June 1944, Howie commanded the 3rd Battalion, 116th Infantry, in the famed 29th Infantry

Division, which landed on Omaha Beach on D-Day. Major Howie's battalion was assigned the difficult mission of capturing the strategic city of St. Lo. Major Howie was killed while giving final orders to the company commanders of his battalion. So gallant were his actions that his division commander paid him the highest military tribute by having his body brought into St. Lo first and parading the division before him as he lay among the ruins of the town cathedral.[lvii]

As in past conflicts, Citadel alumni participated in all the major campaigns of the war, from Pearl Harbor through the major engagements in the European, North African, and Pacific theaters, and at sea. Lt. H.E. Crouch (Class of 1940) flew with Jimmy Doolittle's Tokyo Raiders in the raid on Tokyo in April 1942, America's first offensive action of the war.[lviii] Capt. Jack R. Millar (Class of 1939) flew the plans for the North African invasion to President Roosevelt. Millar had earlier participated in the first B-17 raid over Europe with the 8th Air Force.[lix] Col. Samuel A. Woods, U.S. Marine Corps (Class of 1914), a veteran of France during World War I, China, and Nicaragua, was handpicked to be the first commanding officer of the Marine Corps recruit training camp for African-American marines at Montfort Point, Camp Lejeune, North Carolina.[lx] Later in the war, Colonel Woods was a strong advocate for African-American marines being allowed to serve in combat units rather than labor battalions.[lxi] Among the most highly decorated alumni was Capt. Roland Wooten (Class of 1936) of the Army Air Corps, a highly decorated fighter pilot in North Africa and Europe.[lxii]

Five years after the end of World War II, some 1,500 alumni were on active duty during the Korean War, and 32 graduates were killed in action.[lxiii] Gen. Edwin A. Pollock, USMC (Class of 1921), commanded the 1st Marine Division in Korea and served under Gen. Mark Clark, soon to become the president of The Citadel. During World War II, General Pollock won the Navy Cross as a battalion commander on Guadalcanal while his classmate W.O. Brice commanded Marine Aircraft Group 11 there.[lxiv] General Pollock became the first marine to command both the Fleet Marine Force, Atlantic, and the Fleet Marine Force, Pacific, and retired as a four-star general. General Pollock later served The Citadel as chairman of the Board of Visitors.[lxv]

Gen. Mark W. Clark became president of The Citadel in 1954 upon the retirement of General Summerall, who had served as president for 22 years. General Clark had commanded the 5th U.S. Army in Italy during World War II. He also served as U.S. commissioner for Austria and as commander-in-chief of the United Nations Command in Korea.

The international reputation of The Citadel was strengthened during Clark's administration, and the strength of the Corps of Cadets increased in size to the maximum capacity of the barracks. New construction filled the campus as the Memorial Library and Museum, McCormick Beach Club, Jenkins Hall, Mark Clark Hall, and the Howie Memorial Carillon were constructed.

One of General Clark's most enduring accomplishments was the formalization of the Cadet Honor Code, whereby a cadet does not lie, cheat, or steal, nor tolerate those who do.

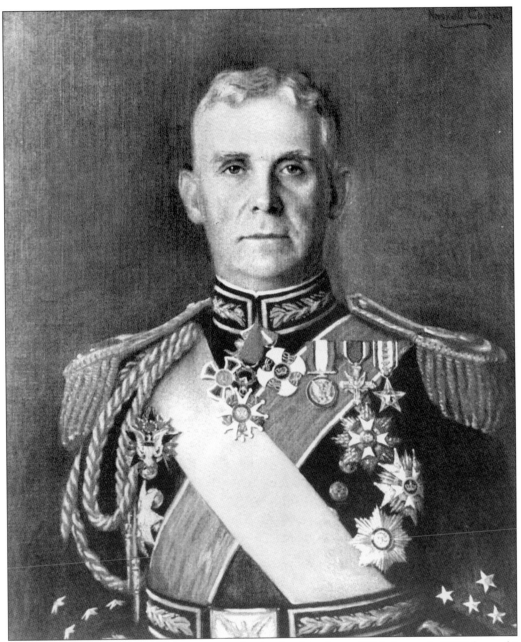

GEN. C.P. SUMMERALL. General Summerall's leadership from 1931 through 1952 brought The Citadel through the tragedy of the Great Depression and the peril of World War II. The international reputation enjoyed by General Summerall brought great acclaim to The Citadel during his administration.

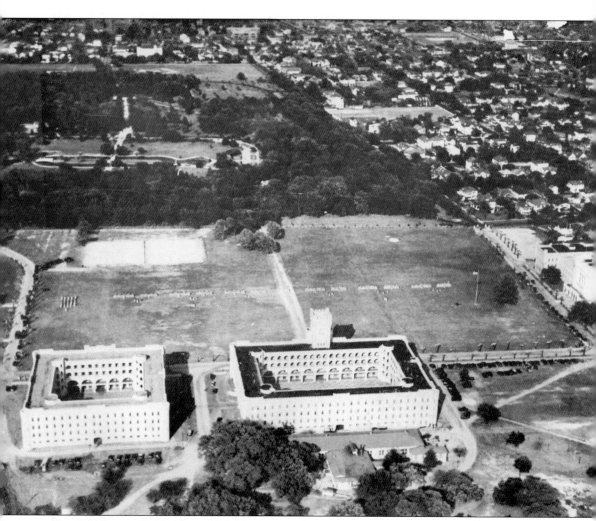

THE CITADEL IN 1932. This view shows Hampton Park to the east of the campus.

SUMMERALL AND PERSHING. In France during World War I, General Summerall served as commanding general of the 1st Infantry Division. He is shown here with Gen. John J. Pershing, the commander of the American Expeditionary Force.

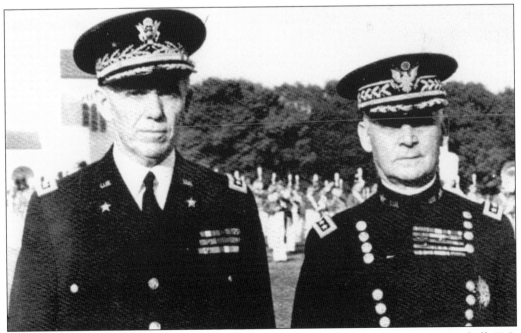

SUMMERALL AND MARSHALL. General Summerall is shown with Gen. George C. Marshall, U.S. Army chief of staff, during General Marshall's visit to The Citadel in April 1940.

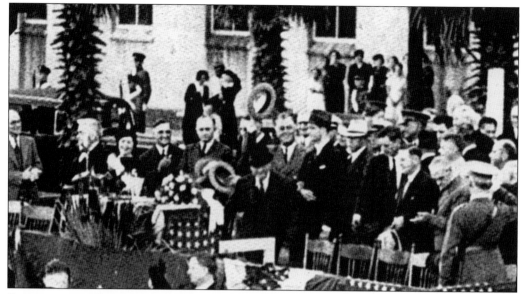

SUMMERALL AND ROOSEVELT. President Franklin Roosevelt visited The Citadel on October 23, 1935. In his remarks, President Roosevelt said, "When that I heard that I was to speak at The Citadel, old memories came back to me. Memories not only of my own visit to the school— an historical record, a war record, if you please, of The Citadel boys that ought to be known to every boy in the United States. Then when I learned that The Citadel had moved, somehow I got a little choky over it, wondering what it would be like; and yet here I come and I find the old Citadel reproduced. It is reproduced, I am confident, for generations to come, for the continuance of this splendid institution. I am happy indeed that you have moved it here to these very fitting surroundings, and that The Citadel is under the command of my old friend General Summerall."

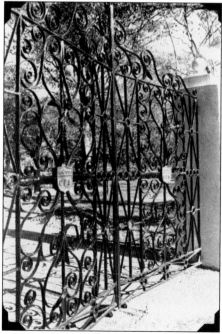

SUMMERALL GATES. The Summerall Gates open on to Hampton Park. According to tradition, they were constructed from panels from the famous Sword Gates made by the noted Charleston ironmonger Christopher Werner.

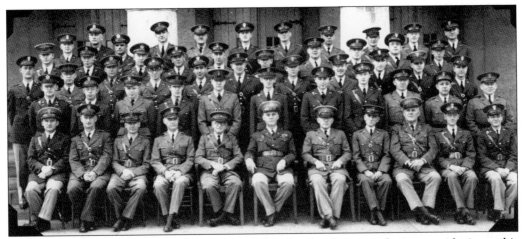

STAFF AND FACULTY IN 1936. The size of the faculty has greatly increased since this photograph, and the vast majority hold terminal degrees in their respective fields. The Citadel emphasizes small class size and a low student-faculty ratio. General Summerall is pictured in the center of the first row.

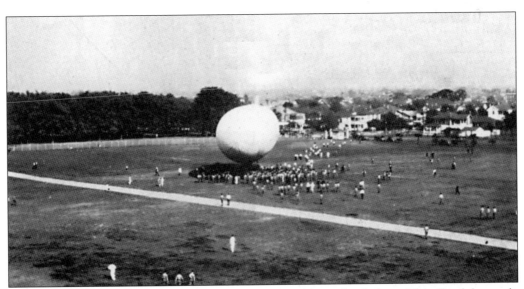

BLIMP ON CAMPUS. During the 1930s, a Goodyear blimp landed on The Citadel parade ground, mistaking it for a landing field.

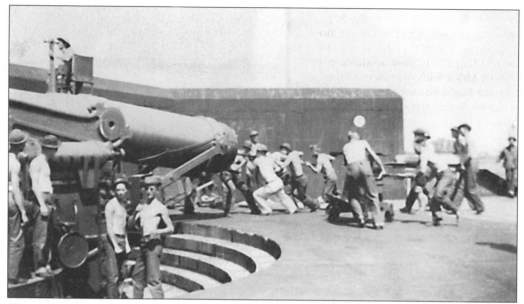

CADETS AT FORT MOULTRIE. During the 1930s, cadets from The Citadel underwent ROTC training at Fort Moultrie as an economic measure in an effort to reduce travel costs.

CADETS WITH A MACHINE GUN ON THE PARADE GROUND. Just before World War II, cadets train with a medium machine gun.

ROLAND WOOTEN (CLASS OF 1936).
Roland Wooten was one of the most highly decorated Citadel alumni in World War II. He flew Spitfires in North Africa with members of the former Eagle Squadron. The Citadel chapter of the Arnold Air Society is named for him.

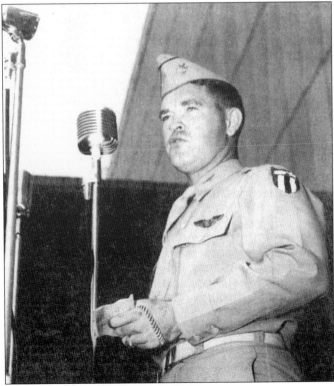

CAPT. JOHN T. MILLAR (CLASS OF 1939). Capt. Jack Millar flew in the first American air raid over occupied Europe. He was later entrusted with flying the plans for the North African invasion from General Eisenhower to President Roosevelt. After service in Europe, he flew numerous missions over the "Hump" in the China-Burma-India theater.

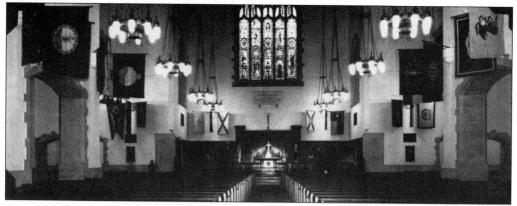

THE INTERIOR OF SUMMERALL CHAPEL. Flags from all states hang in the chapel. This tradition was authorized by General Summerall.

THE EXTERIOR OF SUMMERALL CHAPEL. The flags in Summerall Chapel represent all 50 states. Here, General Summerall is shown accepting a state flag from Tennessee.

COL. SAMUEL A. WOODS (CLASS OF 1914) AND MAJ. T.D. HOWIE (CLASS OF 1929). Col. Sam Woods (left) was the commander of the Marine Corps Recruit Depot for African-American Marines in World War II. Colonel Woods was greatly respected by the "Montfort Point Marines" and did much to assure the success of these Marines. Maj. T.D. Howie (right), the "Major of St. Lo" is perhaps The Citadel's most widely known graduate in World War II.

"THE MAJOR OF ST. LO." This mural by David Humphries Miller shows Major Howie's body being carried into the town of St. Lo after its capture by Howie's troops.

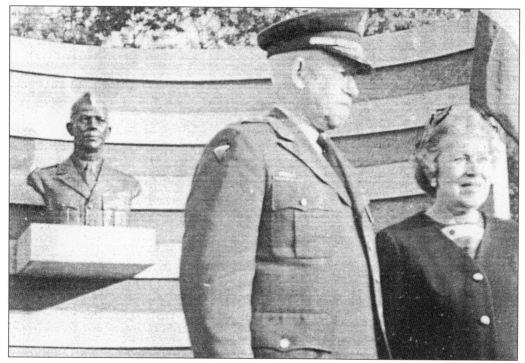

HOWIE MONUMENT IN ST. LO, FRANCE. Tom Howie's widow is shown here at the Howie Monument in St. Lo with General of the Army Omar Bradley. The drill team at Staunton Military Academy in Virginia was named the Howie Rifles in memory of Major Howie.

HOWIE CARILLON. The Howie Carillon, one of the largest in the western hemisphere, was funded in part by gifts from his classmate Hugh Daniel. The armory of the 116th Infantry Regiment, 29th Infantry Division, Virginia National Guard (Howie's Unit), is dedicated to Howie.

LT. HORACE E. CROUCH (CLASS OF 1940).
Lt. "Salley" Crouch took part in the
Doolittle Raid on Tokyo. This raid was
America's first offensive action of the war
and was described by Winston Churchill
as "bold and spectacular." Lieutenant
Crouch and crew bailed out over China
and eventually reached Allied forces. He
flew additional combat missions during
World War II and in Korea.

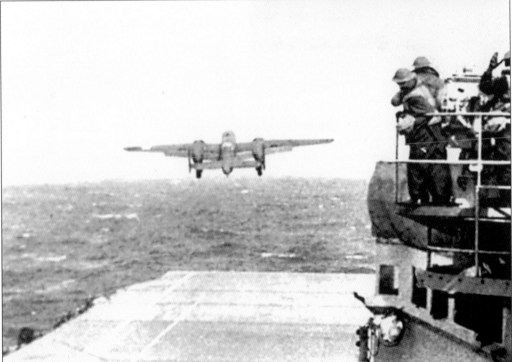

DOOLITTLE TAKE-OFF. One of the raiders' bombers is shown taking off from the USS *Hornet*.

CLASS OF 1942 TOWER. The tower of Padgett-Thomas Barracks has been dedicated in recognition of the extraordinary contributions made by the members of this class. This class produced two governors of South Carolina, two U.S. ambassadors, a U.S. senator, two presidents of The Citadel, and other graduates who achieved remarkable success in the private sector and the military.

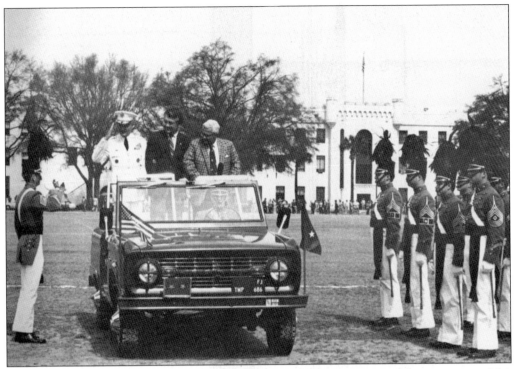

MAJ. GEN. JAMES A. GRIMSLEY JR. (CLASS OF 1942). After a very successful army career, Maj. Gen. James Grimsley (left in vehicle) served as president of The Citadel from 1980 to 1989. He still serves as president emeritus.

LT. GEN. GEORGE M. SEIGNIOUS (CLASS OF 1942). Lt. Gen. George Seignious served as president of The Citadel from 1975 to 1979. He was also ambassador to the Strategic Arms Limitation Talks (SALT) and head of the Atlantic Council of the United States.

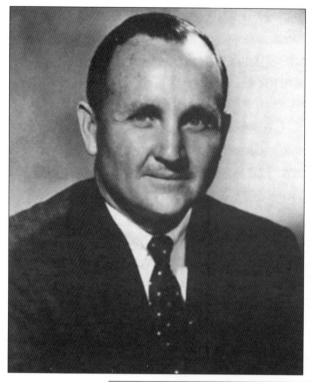

ALVAH H. CHAPMAN (CLASS OF 1942). After service in World War II as a bomber pilot, Alvah Chapman became the president of the Knight-Ridder newspaper chain.

GOV. JOHN C. WEST (CLASS OF 1942). John West served as governor of South Carolina and as the U.S. ambassador to Saudi Arabia. He is shown here (left) with President Jimmy Carter.

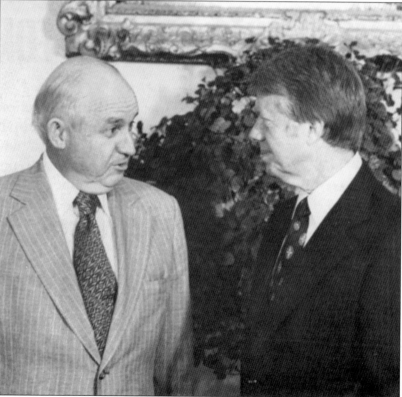

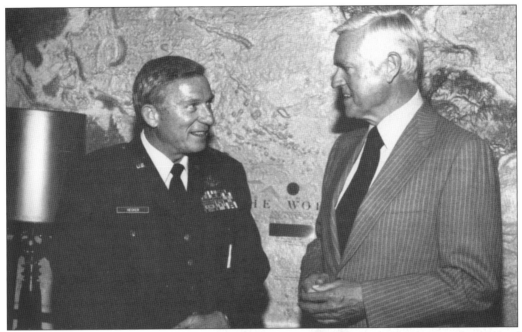

Sen. Ernest F. Hollings (Class of 1942). "Fritz" Hollings (right) served as governor of South Carolina and as a member of the U.S. Senate. He is shown here with Maj. Gen. Guy Heckler, Class of 1954.

Gen. Mark Clark. Gen. Mark Clark served as president of The Citadel from 1954 to 1965. His administration saw one of the greatest periods in Citadel history, with significant progress in all aspects of campus life.

SERAPH MONUMENT. The Seraph Monument commemorates General Clark's secret mission to enemy-held North Africa in 1942. It is a monument to Anglo-American cooperation and is the only shore installation in the United States permitted to fly the Royal Navy Ensign. The monument incorporates parts of the submarine, including the periscope.

MARK CLARK HALL. Mark Clark Hall is the Cadet Activities Building.

GENERAL CLARK AND WINSTON CHURCHILL. General Clark is shown here with Prime Minister Churchill during the Italian Campaign.

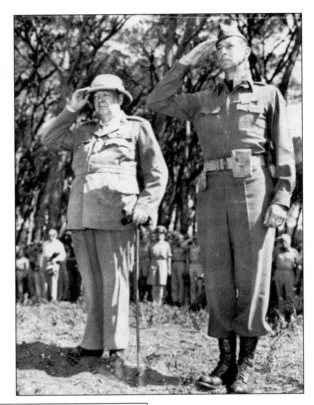

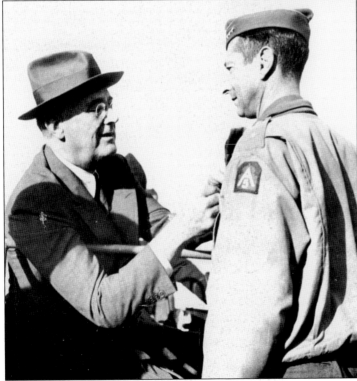

GENERAL CLARK AND PRESIDENT ROOSEVELT. General Clark is shown with President Roosevelt in North Africa.

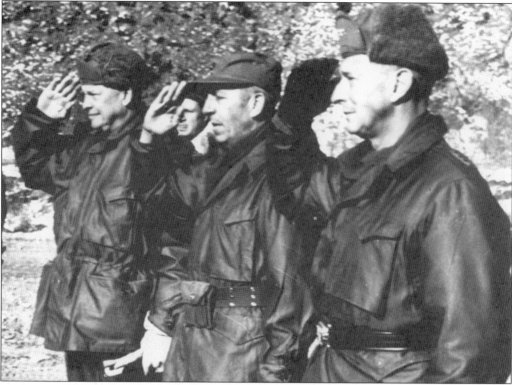

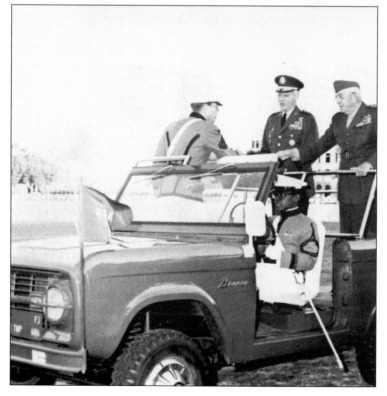

MAJOR GENERAL POLLOCK, MARK CLARK, AND GENERAL EISENHOWER. While serving as UN Commander in Korea, General Clark (right) is shown with President-elect Eisenhower and Gen. E.A. Pollock, U.S. Marine Corps, (center) commanding general of the 1st Marine Division (Class of 1921).

GENERAL POLLOCK. After a distinguished career in the U.S. Marine Corps, General Pollock served as chairman of The Citadel Board of Visitors.

THE CITADEL BAND AT EISENHOWER'S INAUGURATION. The Citadel Band attended its first presidential inauguration in 1956.

CLARK AND EISENHOWER AT THE CITADEL. President Eisenhower visited The Citadel early in the Clark administration and was awarded an honorary degree.

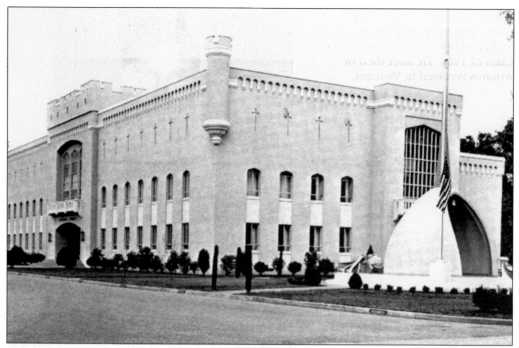

MEMORIAL LIBRARY. The library is now named for C.E. Daniel, Class of 1918, and Hugh Daniel, Class of 1929. The Daniel brothers were major benefactors of The Citadel.

VIEW FROM BOND HALL. This view shows the library, which was built during the administration of General Clark, and the chapel.

CADET SAM BIRD, CLASS OF 1961.
Cadet Sam Bird served as the regimental executive officer in the Class of 1961. He later died of wounds received in Vietnam.

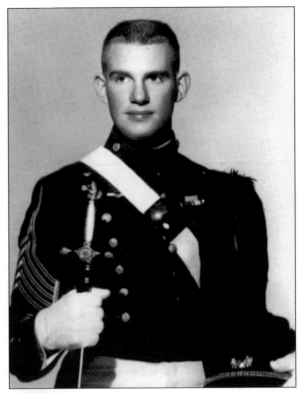

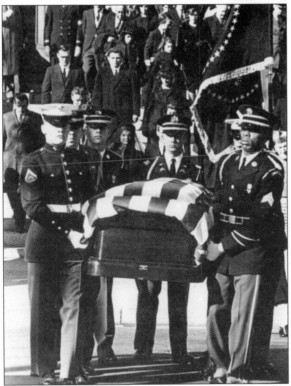

KENNEDY FUNERAL. Lieutenant Bird, center, was widely praised for his service as the commander of the funeral detail for President John F. Kennedy in November 1963.

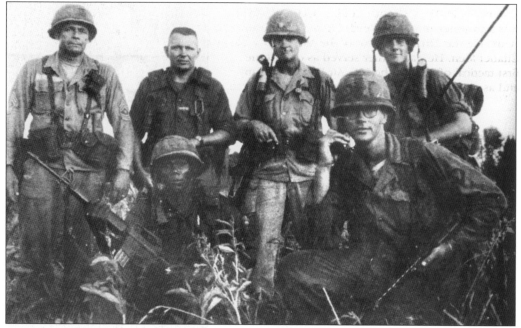

Capt. Thomas Metsker, Class of 1961. Capt. Tom Metsker (far right, back row) is shown with the command group of the 1st Battalion, 7th U.S. Cavalry, just before assaulting the North Vietnamese forces in the Ia Drang Valley in November 1965, the first major air-mobile assault in history. Captain Metsker was killed in this operation a few hours after this photograph was taken when he gave up his place in a med-evac helicopter for another officer who was more seriously wounded than he. His sacrifice was told in the book *We Were Soldiers Once, and Young* by Lt. Gen. Hal Moore, U.S. Army (Ret.) and Joe Galloway. Lieutenant Colonel Moore is second from right in the back row. (Photograph courtesy Joe Galloway.)

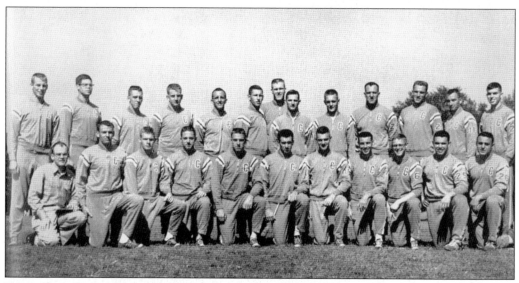

Track Team at the Southern Conference Championships. The 1961 track team was one of the most successful athletic teams in Citadel history. Cadet Tom Metsker (back row, fifth from left) is believed to be the first varsity athlete to be killed in action in Vietnam.

Collins as POW. J. Quincy Collins (Class of 1953) was a prisoner of war in North Vietnam for seven years. He was later president of the Association of Citadel Men. He had earlier served as one of the first tactical officers at the U.S. Air Force Academy and as an exchange officer with the Royal Air Force.

Jenkins Hall. Jenkins Hall houses the military service departments.

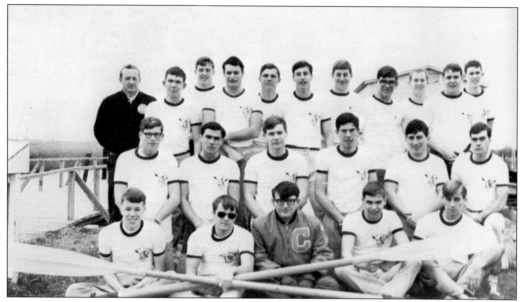

CITADEL CREW TEAM OF 1969. The Citadel crew team was one of the first rowing teams in the South.

CADETS IN WINTER. Cadets are shown here in their winter uniforms.

Six

THE PRESENT CITADEL

Following the administration of General Clark, a number of distinguished men have served as president of The Citadel. Gen. Hugh P. Harris was president from 1965 to 1970, following his service as commanding general of the Continental Army Command and vice chief of staff of the U.S. Army. He was succeeded by Maj. Gen. James W. Duckett (Class of 1932), who served from 1970 to 1974 after a distinguished career on the faculty. In 1974, Lt. Gen. George M. Seignious II (Class of 1942) assumed office. General Seignious resigned in 1979 after being appointed by President Carter as U.S. ambassador to head the Arms Control and Disarmament Agency. He later headed the prestigious Atlantic Council in Washington, D.C.

Vice Adm. James B. Stockdale, U.S. Navy (Ret), a former prisoner of war in Vietnam and recipient of the Medal of Honor, was president from 1979 to 1980. In December 1980, Maj. Gen. James A. Grimsley, U.S. Army (Ret), Class of 1942, was selected as president, serving until 1989. General Grimsley still serves The Citadel as president emeritus. Lt. Gen. Claudius E. Watts III, U.S. Air Force (Ret), Class of 1958, took office in 1989 and served until 1996.

Maj. Gen. John S. Grinalds, U.S. Marine Corps (Ret), a graduate of the United States Military Academy and a former Rhodes Scholar, assumed the presidency in the summer of 1997. After becoming the first graduate of the United States Military Academy to be commissioned directly into the Marine Corps since 1914, General Grinalds was awarded a Rhodes Scholarship and earned a second bachelor's and a master's degrees from Brasenose College of Oxford University. He later received a Master's of Business Administration, with distinction, from the Harvard Business School and served as a White House Fellow. During his 32-year career in the U.S. Marine Corps, he was awarded a Silver Star for heroism in Vietnam and served as an advisor to the NATO supreme allied commander Europe and to the chairman of the joint chiefs of staff.

Citadel men again fought and died during the Vietnam War. Capt. Terry D. Cordell (Class of 1957), an Army Special Forces officer, was the first of 65 Citadel men who died in that war. Capt. Thomas C. Metsker, U.S. Army (Class of 1961), was killed in action participating in the first air-mobile assault in history with the 1st Battalion of the 7th Cavalry, 1st Cavalry

Division, in November 1965.[lxvi] Several Citadel graduates were prisoners of war in North Vietnam, including Capt. Quincy Collins, U.S. Air Force (Class of 1953), a former president of the Association of Citadel Men. Maj. Samuel A. Bird (Class of 1961), who led the funeral detail during the funeral of President John F. Kennedy in November 1963, died of wounds received in Vietnam.[lxvii]

The first African-American cadet, the late Charles D. Foster (Class of 1970), was admitted in 1966. Since that time, African-American graduates have gone on to distinguished careers in the military services and in the public and private sectors, and they have served on the Board of Visitors of The Citadel.

As always, Citadel men have continued to sacrifice for the nation in times of conflict. Citadel graduates made the supreme sacrifice in Grenada; in the terrorist bombing of the U.S. Marine barracks in Beirut, Lebanon; and in the Gulf War in 1991. Twenty-two cadets were called to active duty with reserve and national guard units in that conflict. Another Gulf War veteran, Stephen Buyer (Class of 1980), now serves as a member of the U.S. Congress from Indiana. The first United States battle casualty in the war with Iraq in 2003 was 2d Lt. Therrel S. Childers, U.S. Marine Corps (Class of 2001). Lieutenant Childers had attended The Citadel with the Marine Corps Enlisted Commissioning Education Program, under which a select number of marines attend The Citadel to receive a degree and qualify for a commission.

A historic event occurred in the summer of 1996, when the Board of Visitors voted to admit women into the Corps of Cadets as members of the Class of 2000. Shannon Faulkner had entered The Citadel the previous year pursuant to court order but left the college shortly after entering. Four women entered in the fall of 1996, and two very successfully completed their first year as fourth-class cadets.

Nancy Mace, daughter of Brig. Gen. J. Emory Mace, U.S. Army (Ret) (Class of 1963) and a commandant of cadets, became the first female cadet graduate in 1999. Petra Lovetinska, Class of 2000, a native of Czechoslavakia, became the first female cadet graduate to receive a commission in the U.S. Armed Forces, and she served as a lieutenant in the U.S. Marine Corps in Iraq.

Then-governor George W. Bush of Texas chose The Citadel to deliver a major policy speech outlining his vision on national defense issues during the 2000 presidential campaign. Governor Bush remarked, "The Citadel is a place of pride and tradition. A place where the standards are high, the discipline is strong, and leaders are born. The men, and now women, of this institution represent a sense of honor and accomplishment. I am proud to be with you today."[lxiii] As President, George W. Bush again visited The Citadel on December 11, 2001, following the terrorist attack on New York on September 11, 2001. President Bush set forth his vision for the future of the military forces of the United States and for the conduct of the war against terrorism.

The Citadel campus has seen much growth in recent years with the addition or replacement of many buildings to enhance significantly the academic facilities. The severe damage inflicted by Hurricane Hugo in 1989 has all but disappeared. In recent years, The Citadel has survived the devastating effects of a major hurricane, social change as women became members of the Corps of Cadets, economic pressures, and the effects of war with the tragic deaths of young alumni. Throughout all of these events, The Citadel has emerged as a stronger institution, and it now faces an even brighter future.

PRINCE CHARLES VISITS. The visit of Prince Charles to The Citadel in 1977, where he was awarded an honorary degree, was filled with pomp and ceremony.

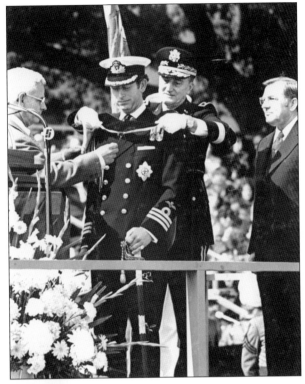

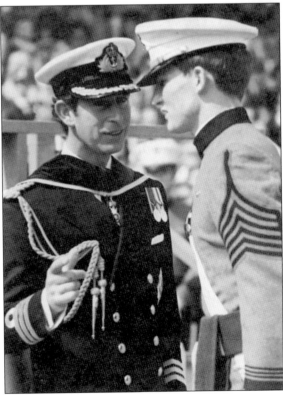

PRINCE CHARLES VISITS. Prince Charles speaks to the regimental commander before parade.

CADET JOSEPH SHINE (CLASS OF 1971). One of the first African-American graduates, Joe Shine went on to graduate from Harvard Law School. After service in the U.S. Air Force, he served in high positions in the South Carolina state government. Shortly before his untimely death, he had been selected to serve on The Citadel Board of Visitors.

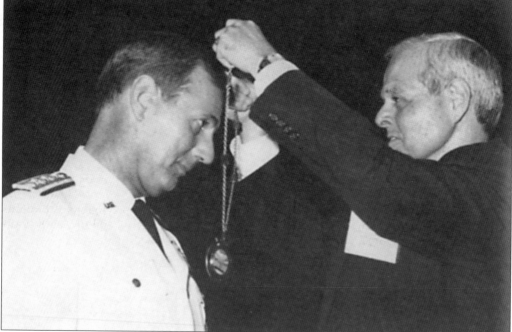

LT. GEN. CLAUDIUS WATTS (CLASS OF 1958). Gen. "Bud" Watts (left) served as president of The Citadel from 1989 to 1996, after a very successful career in the U.S. Air Force. General Watts earned an M.B.A. from Stanford University and flew combat missions in Vietnam. He is shown here at his inauguration.

DR. JOHN M. PALMS (CLASS OF 1958). Dr. John Palms was chosen as president of Georgia State University in Atlanta, Georgia. Dr. Palms went on to serve as president of the University of South Carolina. Other Citadel graduates have led other prestigious institutions of higher learning, including Trinity College, the University of Hawaii, and the law schools at the University of Georgia and the University of South Carolina.

BOND VOLUNTEERS TRAINING. After an arduous selection process, members of the second class (juniors) are selected for membership in the Bond Volunteers, the junior drill team. This photograph is from the 1970s.

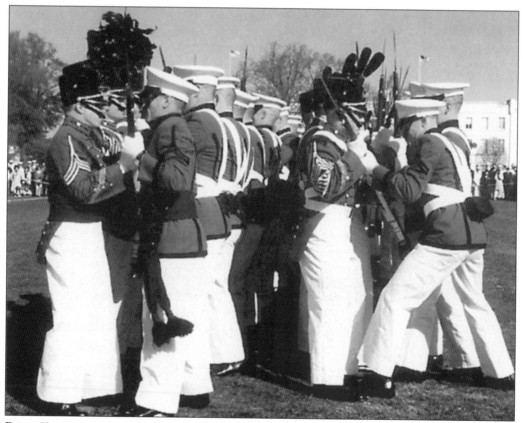

BOND VOLUNTEERS AND SUMMERALL GUARDS RIFLE EXCHANGE. On Corps Day in March each year, the traditional rifle exchange is held when the rising members of the first class become Summerall Guards, the senior drill team.

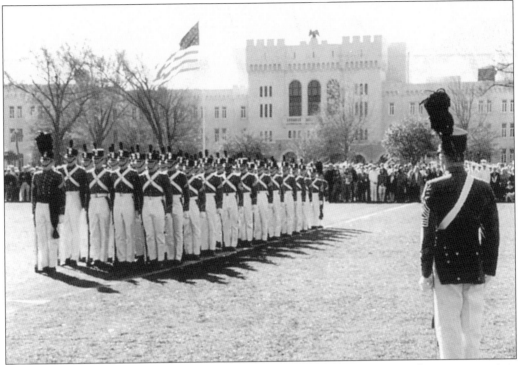

SUMMERALL GUARDS. The Summerall Guards perform on the parade ground at Homecoming.

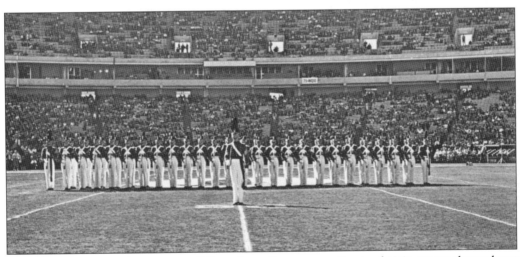

SUMMERALL GUARDS. The Summerall Guards perform at sporting and civic events throughout the nation.

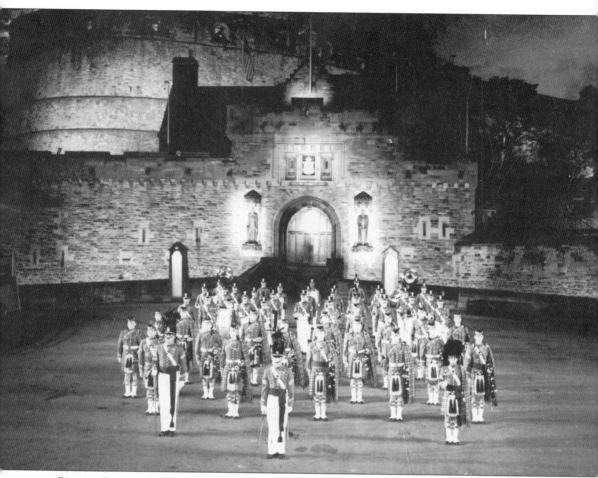

CITADEL PIPES AND DRUMS AT THE EDINBURGH TATTOO. The Citadel Bagpipe Band was begun during the administration of General Clark. The Regimental Band and Bagpipes was the first military college band invited to participate in the Edinburgh Military Tattoo, one of the most prestigious military events in the world.

CADET HONOR COURT AND HONOR CODE. One of General Clark's most important legacies was the formalization of the Cadet Honor Code, whereby a cadet does not lie, cheat, or steal, nor tolerate those who do.

BISHOP ALBERT S. THOMAS AND THE CADET PRAYER. Bishop Albert S. Thomas (Class of 1892) wrote the Cadet prayer:

> Almighty God, the source of light and strength, we implore Thy blessing on this our beloved institution, that it may continue true to its high purposes. Guide and strengthen those upon whom rests the authority of government; enlighten with wisdom those who teach and those who learn; and grant to all of us that through sound learning and firm leadership, we may prove ourselves worthy citizens of our country, devoted to truth, given to unselfish service, loyal to every obligation of life and above all to Thee. Grant to each one of us, in his/her own life, an humble heart, a steadfast purpose, and a joyful hope, with a readiness to endure hardship and suffer if need be, that truth may prevail among us and that Thy will may be done on earth. *Through Jesus Christ our Lord. *optional

103

WASHINGTON LIGHT INFANTRY. A long history of camaraderie exists between the Corps of Cadets and the Washington Light Infantry (W.L.I.), one of the nation's oldest militia units. Cadets from the new Citadel Academy relieved the old guard of W.L.I. members when the academy was founded. The W.L.I. was instrumental in the reopening of the Citadel in 1884. One of the athletic fields is Washington Light Infantry Field. The buttons on the cadets' uniforms are the same as those on W.L.I. uniforms.

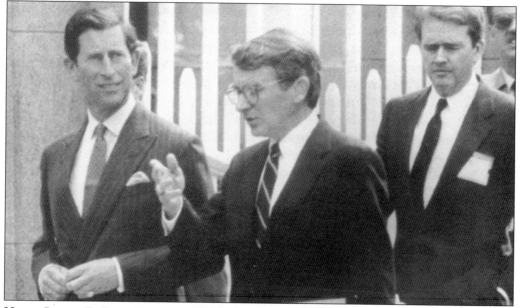

MAYOR JOSEPH P. RILEY (CLASS OF 1964). Mayor Joseph P. Riley is the first Citadel graduate to serve as mayor of Charleston. He was first elected in 1975. He is shown here with Prince Charles.

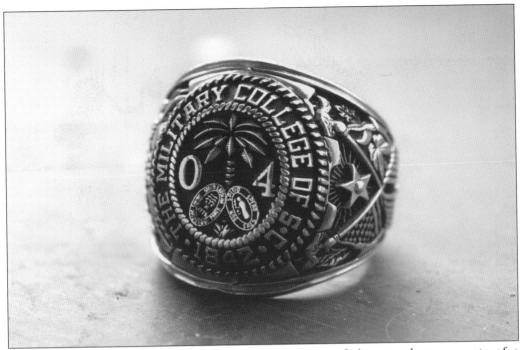

CITADEL RING. Receiving the Citadel class ring is one of the proudest moments of a cadet's career.

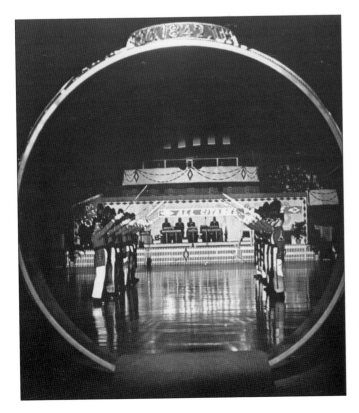

JUNIOR SWORD DRILL. The Junior Sword Drill, which was formerly performed at the Ring Hop, formed an arch of sabers through which a cadet and his date passed.

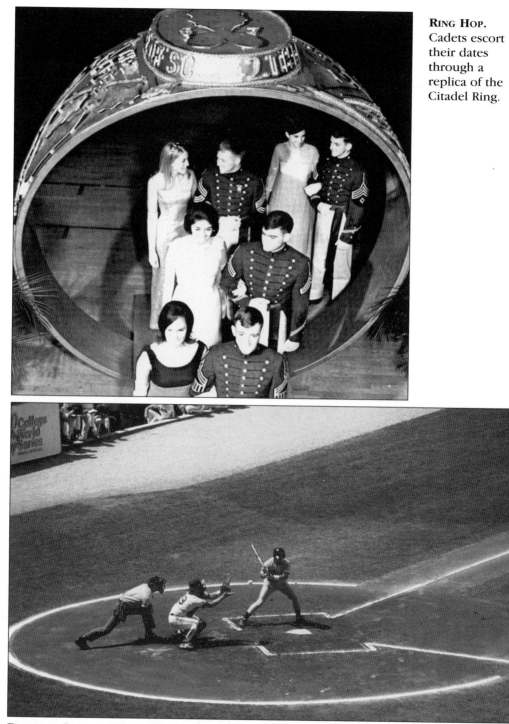

BASEBALL COLLEGE WORLD SERIES. In 1990, The Citadel baseball team participated in the College World Series in Omaha, Nebraska. The first baseball team was started at the Citadel in 1886. In 1960, The Citadel team was the co-champion of the Southern Conference, and it has won subsequent conference championships.

FOURTH-CLASS SYSTEM. The hallmark of The Citadel experience is the fourth-class system, a demanding, year-long training period. The Citadel has the most challenging plebe system in the country. Here, a "cadet recruit" reports to the upperclass training cadre.

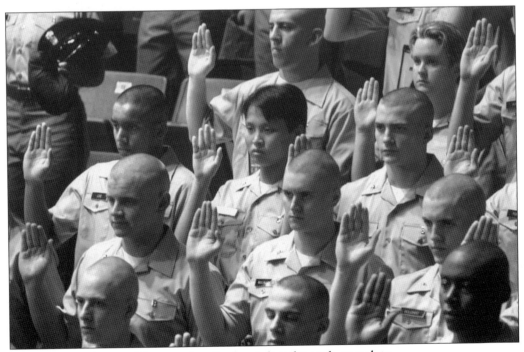

FOURTH-CLASS SYSTEM. The new fourth class takes the oath as cadets.

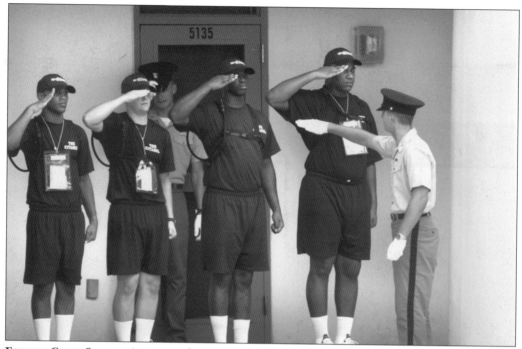

FOURTH-CLASS SYSTEM. An upperclassman instructs the new "knobs" in saluting.

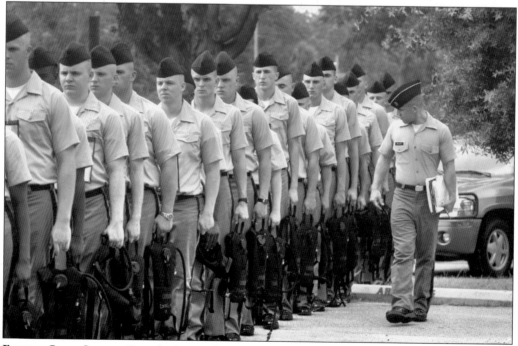

FOURTH-CLASS SYSTEM. Fourth-class cadets are shown here at drill.

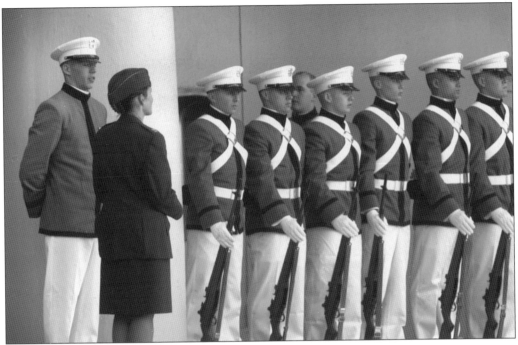

FOURTH-CLASS SYSTEM. A squad of fourth-class cadets stand for Parents Day.

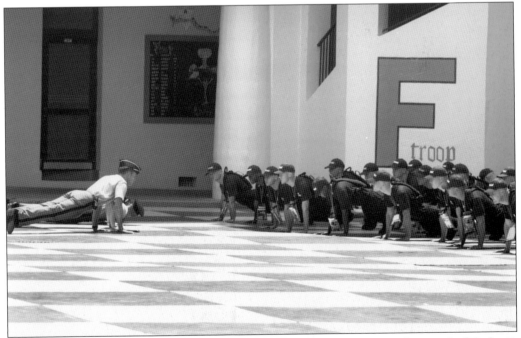

FOURTH-CLASS SYSTEM. Here, fourth-class men perform exercises on the quad of Padgett-Thomas Barracks.

RECOGNITION. The Recognition Ceremony officially ends the fourth-class year, and the cadet becomes an upperclassman. Here the cadets grasp their company guidon.

CAPT. ALEX WORTH (CLASS OF 1940) AND COL. WILLIAM O. DARBY OF THE 1ST RANGER BATTALION. Capt. Alexander Worth (left) served as a company commander in the legendary Darby's Rangers during World War II before he was severely wounded. He is shown here with Colonel Darby. The first Ranger unit was Roger's Rangers in the French and Indian War, and the concept of these elite units was revived during World War II. Captain Worth was the first of many Citadel graduates to earn the right to be called "Ranger."

CADET RICHARD O. STEWART (CLASS OF 1968). Capt. Richard O. Stewart was the first Citadel graduate inducted into the Ranger Hall of Fame at Fort Benning, Georgia. Captain Stewart was recognized for his service in Vietnam, where he was severely wounded, and for his service to the Ranger Committee..

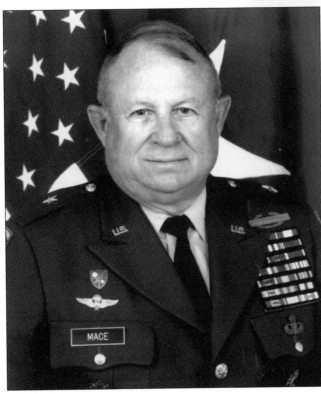

BRIG. GEN. JAMES EMORY MACE (CLASS OF 1963). Brig. Gen. James E. Mace served as the first commanding general of the Ranger Training Brigade at Fort Benning, Georgia. He was later commandant of cadets at The Citadel. General Mace is one the most highly decorated alumni of The Citadel.

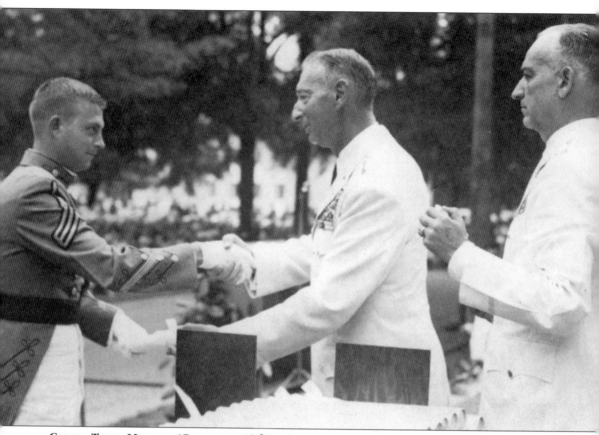

CADET TONY MOTLEY (CLASS OF 1960) GRADUATES. Langhorn A. ("Tony") Motley was appointed by President Reagan to serve as U.S. ambassador to Brazil. Here he receives his diploma from General Clark. The first of many Citadel graduates to serve as a U.S. ambassador was Thomas B. Ferguson, Class of 1861. He was a member of the *Star of the West* Battery. Ferguson was wounded as an artillery officer in an 1863 battle in Mississippi. He was appointed Minister to Norway and Sweden in 1894 by President Cleveland.

ASSISTANT SECRETARY OF STATE MOTLEY WITH PRESIDENT REAGAN. After service as an ambassador, Motley was appointed assistant secretary of state for Latin American affairs. He is shown here in the White House.

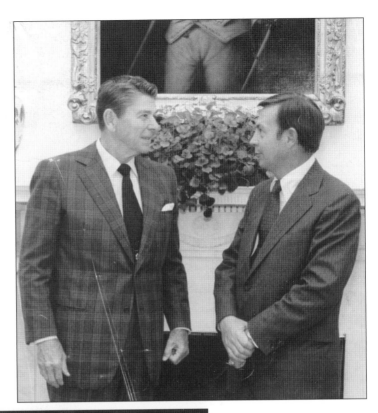

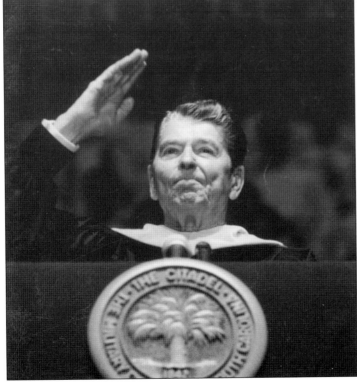

PRESIDENT REAGAN AT GRADUATION. Former President Reagan delivered the graduation address in 1993.

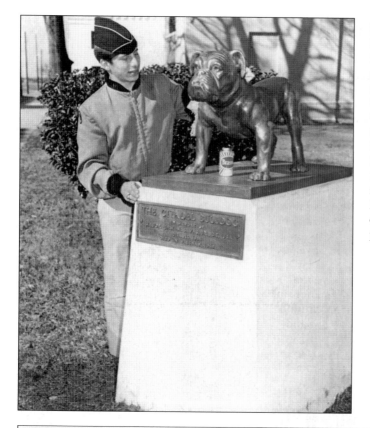

BULLDOG MONUMENT. The Bulldog Monument was cast from brass contributed by cadets in the 1960s in a project spearheaded by Maj. Sam Savas Jr., U.S. Army, Class of 1951. Major Savas died in Vietnam shortly after leaving The Citadel. His son, Lt. Sam Savas III (Class of 1979), is shown here at the monument. Tragically, Lieutenant Savas also died on active duty as a navy pilot.

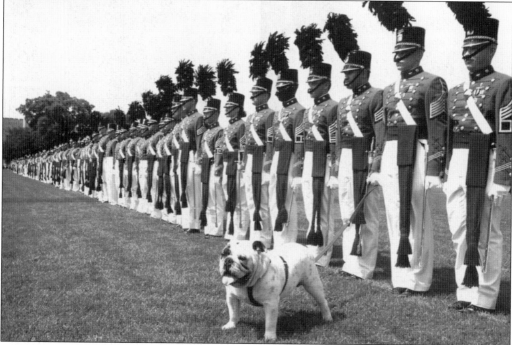

BULLDOG AT PARADE. The new bulldog mascot is presented to the corps at a parade.

ARLAND D. WILLIAMS, CLASS OF 1957. Arland D. Williams was the hero of the Air Florida disaster of January 13, 1982. The aircraft on which Williams was a passenger crashed into the icy Potomac River just after take-off from Washington's National Airport. Williams caught a rope dropped from a rescue helicopter, and he repeatedly passed the line to others in the water. After five passengers had been rescued, the helicopter returned for Williams, who had by then slipped under the frigid water. In his address to the graduating class of 1993, President Ronald Reagan said of Williams, "But when the challenge came he was ready. . . . He brought honor to his alma mater, and to his nation. . . . Greater love, as the Bible tells us, hath no man than to lay down his life for a friend. I have spoken of Arland Williams in part to honor him anew in your presence, here at this special institution that helped mold his character." The Arland Williams Society was established at The Citadel to honor Citadel alumni who have performed outstanding public service in a civilian capacity.

REP. STEVE BUYER (CLASS OF 1980). Congressman Steve Buyer serves as a member of Congress from Indiana. Congressman Buyer practiced law in Indiana and served in the Gulf War prior to his election to Congress. He is a co-founder of the Reserve Caucus in Congress. He is shown here being promoted to colonel in the U.S. Army Reserve by President George W. Bush.

ASSIMILATION OF WOMEN. The first women entered the Corps of Cadets in 1996. Two of these cadets successfully completed the fourth-class year. Cadets Petra Lovetinska and Nancy Mace are shown in Padgett-Thomas Barracks.

CADETS LOVETINSKA AND MACE. Petra Lovetinska and Nancy Mace stand together as upperclassmen.

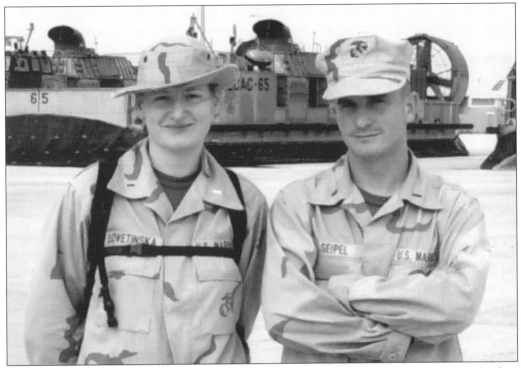

LIEUTENANT LOVETINSKA. Lt. Petra Lovetinska (Class of 2000), U.S. Marine Corps, was the first female graduate to receive a commission. She is shown here in Kuwait during Operation Iraqi Freedom.

ASSIMILATION OF WOMEN. Female cadets now occupy leadership roles in the Corps of Cadets.

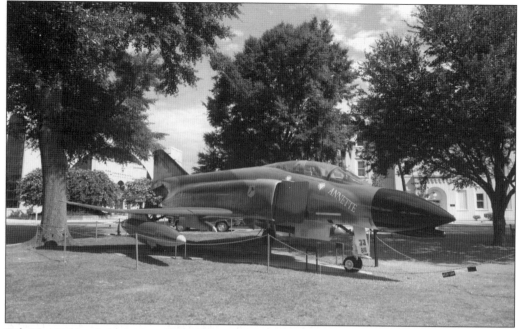

F-4. The F-4 jet-fighter aircraft on The Citadel parade ground was flown in Vietnam by Elie G. Shuler (Class of 1959). Lieutenant General Shuler later commanded the 8th Air Force in the Gulf War.

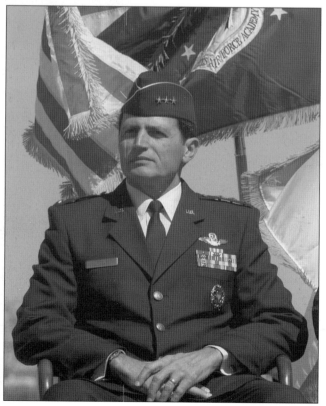

Lt. Gen. John Rosa (Class of 1973). Lt. Gen. John Rosa serves as superintendent of the U.S. Air Force Academy in Colorado Springs, Colorado.

CADET CONROY (CLASS OF 1967) AND BOO (CLASS OF 1938). One of America's most widely read authors is Pat Conroy (right). He is the author of such novels as *The Boo, The Water is Wide, The Great Santini, Beach Music,* and *My Losing Season.* He is shown here with Lt. Col. T. Nugent Courvoisie (Class of 1938), the legendary assistant commandant of cadets, the subject of his first book.

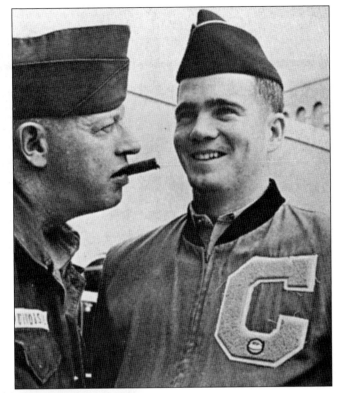

PAT CONROY AND LIEUTENANT COLONEL COURVOISIE RECEIVE THE PALMETTO AWARD. Pat Conroy (left) and the Boo receive the Palmetto Award, one of the highest honors The Citadel can bestow.

WILLIAM H. THOMAS. Three generations of Citadel men are shown in this picture: Lt. Col. William H. Thomas (Class of 1971); his son, William B. Thomas, a member of the Class of 2006; and his father, Lt. Col. William H. Thomas Jr., a member of the Class of 1945. Cadet Thomas is shown graduating from Marine Corps Recruit Training at Parris Island. As a cadet, he will serve in the Marine Corps Reserve.

MAJ. GEN. JOHN S. GRINALDS, U.S. MARINE CORPS (RET). Maj. Gen. John S. Grinalds assumed the position of president of The Citadel in 1997.

MARINE ENLISTED COMMISSIONING EDUCATION PROGRAM (MECEP). Highly selected enlisted marines attend The Citadel to receive their degrees and a commission in the U.S. Marine Corps. The first U.S. casualty in the war in Iraq was a MECEP graduate of The Citadel, 1st Lt. Therrell Shane Childers, U.S. Marine Corps, Class of 2001.

CITADEL RINGS. Here a group of cadets celebrate after receiving their rings.

COLLEGE OF GRADUATE AND PROFESSIONAL STUDIES. Since 1972, The Citadel has admitted female students through the evening college. This program has been expanded to offer undergraduate and graduate programs to residents of the Lowcountry. These programs do not affect the cadet program, which remains the centerpiece of the college.

COL. J.A.W. REMBERT (CLASS OF 1961). Col. James A.W. Rembert is a long-term member of the English faculty. As a cadet, Colonel Rembert held high rank, and after graduation he served as an Army Special Forces officer, attending Ranger and Airborne Schools. He went on to earn doctoral degrees in English literature from the University of North Carolina and Cambridge University. While at Cambridge, Colonel Rembert rowed for the St. Edmund's House crew team.

FOOTBALL GAME. Football was first played at The Citadel in 1907, after the cadets petitioned the Board of Visitors for permission to field a team. Since then, The Citadel has produced a number of highly successful players, including "Stump" Mitchell, John Small, Paul Maguire, and Travis Jervey. In 1961, The Citadel was the Southern Conference champion. An early sports writer described the cadets as having bulldog tenacity, and the name "Bulldog" has remained.

CORPS AT A FOOTBALL GAME. The corps rallies before the march-on for a home game.

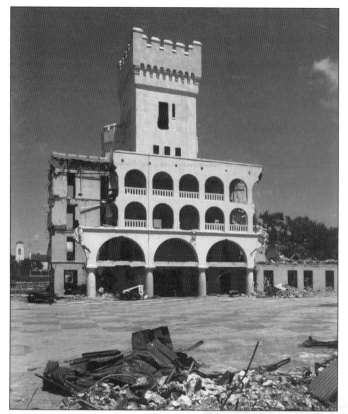

DEMOLITION OF PADGETT-THOMAS BARRACKS. The signature Padgett-Thomas Barracks was demolished to make way for a new structure that meets all modern codes. The replacement barracks is virtually indistinguishable from the original.

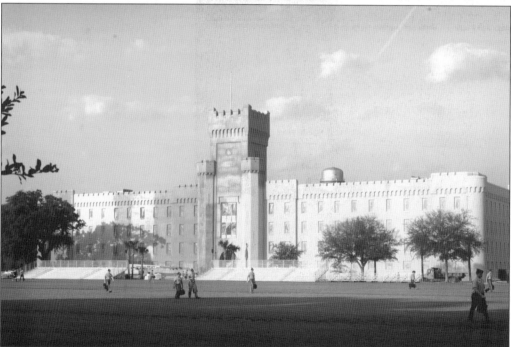

PADGETT-THOMAS BARRACKS. The new Padgett-Thomas Barracks are shown here in July 2004.

CADETS IN PARADE WHITES. The white dress uniform is often worn for parades and other functions during spring.

PRESIDENT BUSH AT THE CITADEL. President George W. Bush chose The Citadel to deliver a major foreign policy speech after the September 11, 2001 terrorist attack.

125

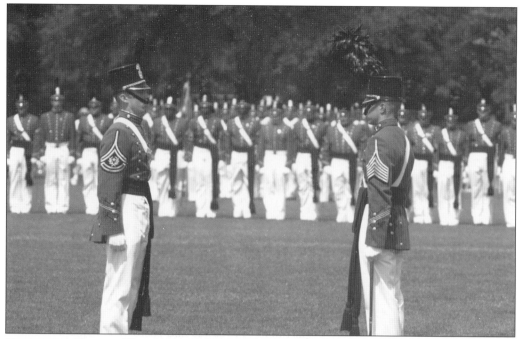

GRADUATION PARADE. The regimental commander of the graduating class passes command of the Corps of Cadets to his successor.

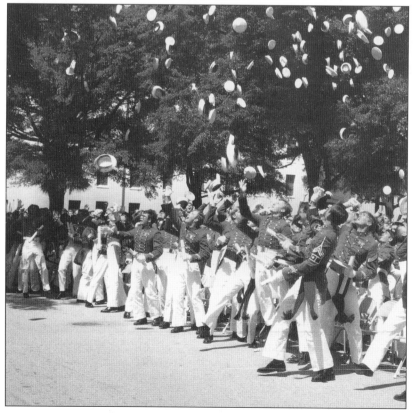

GRADUATION. New graduates toss their caps in the traditional last act as cadets.

NOTES

[i] Terry W. Lipscomb, *South Carolina in 1791: George Washington's Southern Tour* (Columbia, SC: South Carolina Department of Archives and History, 1993), 29.

[ii] ibid., 30.

[iii] John P. Thomas, *The History of the SCMA* (Charleston, SC: Walker, Evans & Cogswell, 1893), 11.

[iv] Lipscomb, 30.

[v] O.J. Bond, *The Story of The Citadel* (Richmond, VA: Garrett and Massie, 1936), 7.

[vi] W.H.J. Thomas, "Architecture Follows Old Citadel Style," *Charleston News and Courier* and *Charleston Evening Post*, 19 March 1971.

[vii] Bond, 7.

[viii] Thomas, 19.

[ix] Bond, 14.

[x] ibid., 16.

[xi] ibid., 25–26.

[xii] ibid., 29.

[xiii] ibid., 33.

[xiv] Thomas, 59.

[xv] ibid., 472.

[xvi] Bond, 41.

[xvii] ibid., 45.

[xviii] Roy Meredith, *Storm Over Sumter* (New York: Simon and Schuster, 1957), 63–64.

[xix] Bond, 50.

[xx] ibid., 55.

[xxi] ibid., 58.

[xxii] Edwin B. Coddington, *The Gettysburg Campaign* (New York: Charles Scribner's Sons, 1984), 402.

[xxiii] Robert E.L. Krick, "Tragedy In the Wilderness," *Civil War Times* 45, 26–27.

[xxiv] Robert Douthat Meade, "Micah Jenkins," *Dictionary of American Biography*, ed. Dumas Malone (New York: Charles Scribner's Sons, 1932), 5:49.

[xxv] Gary R. Baker, *Cadets In Gray* (Columbia, SC: Palmetto Bookworks, 1989), 186–87.

[xxvi] Thomas, 267; Coddington, 57, 525.

[xxvii] Ralph W. Donnelly, *The Rebel Leathernecks* (Shippensburg, PA: White Main, 1989), 229.

xxviii Baker, 145.

xxix ibid., 187.

xxx Baker, 145, 186–89; Meade; Thomas, 267, 270; Coddington, 57, 525.

xxxi Baker, 55.

xxxii ibid., 101.

xxxiii Thomas, 200–201; Jerry Korn, *Pursuit To Appomattox* (Alexandria, VA: Time-Life Books, 1987), 143.

xxxiv Bond, 95.

xxxv ibid., 103.

xxxvi Thomas, 342.

xxxvii Thomas, 382; Bond, 116.

xxxviii Bond, 136.

xxxix James J. Baldwin III, *The Struck Eagle* (Shippensburg, PA: Burd Street Press, 1996), 277.

xl ibid., 358.

xli Thomas, 473.

xlii Bond, 135–36.

xliii ibid., 137.

xliv ibid., 149, 161.

xlv Thomas, 317, 554.

xlvi Bond, 167–70

xlvii ibid., 186.

xlviii ibid.

xlix James Srodes, *Allen Dulles: Master of Spies* (Washington, D.C.: Regnery Publishing, 1999), 217.

l Bond, 186–88.

li ibid., 193.

lii ibid.

liii ibid., 202.

liv *The Guidon 2003–2004* (Charleston, SC, 2003), 33.

lv Col. John F. Williams, U.S. Army, 6 May 1959.

lvi D.D. Nicholson, *The History of The Citadel: The Years of Summerall and Clark* (Charleston, SC: Association of Citadel Men, 1994), 173.

lvii Stephen E. Ambrose, *Citizen Soldiers* (New York: Simon and Schuster, 1997), 74–76.

lviii Craig Nelson, *First Heroes* (New York: Viking, 2002), xvii.

lix *Marietta (Georgia) Daily Journal*, 6 August 1995.

lx Brig. Gen. E.H. Simmons, U.S. Marine Corps (Ret), *Fortitudine,* XXI (1991).

lxi ibid.

lxii Williams, *supra.*

lxiii ibid.

lxiv Richard B. Frank, *Guadalcanal* (New York: Penguin, 1990), 409.

lxv *Alumni News* (Charleston, SC: The Citadel, Winter 1981).

lxvi Lt. Gen. Harold G. Moore, U.S. Army (Ret) and Joseph L. Galloway, *We Were Soldiers Once, and Young* (New York: Random House, 1992), 128.

lxvii Annette Bird and Tim Prouty, *So Proudly He Served* (Wichita, KS: Okarche Books, 1993), 397.

lxviii Gov. George W. Bush, Remarks at The Citadel, 23 September 1999.